IMAGES
of America

BURLEITH

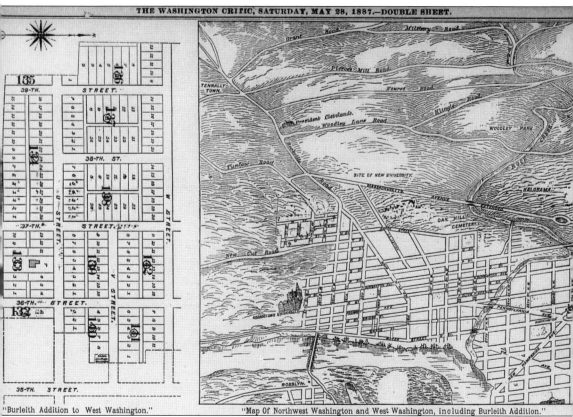

In May 1887, the *Washington Critic* published this map of the Burleith Addition to West Washington. Frederic Huidekoper had acquired Richard Smith Cox's Burleith tract in 1886 and subdivided it for development. In March 1923, the real estate firm Shannon & Luchs reported the purchase of Huidekoper's property and began the Burleith development, which is responsible for the majority of the homes in today's Burleith neighborhood. (*Washington Critic*.)

ON THE COVER: This 1958 image shows Charles Volkman, known to his friends as "Charlie," sitting at the wheel of his spanking new Pontiac Chieftain in front of his 3548 T Street house. His house is one of 17 row houses designed by architect William P. Cissel and built by Thomas R. Riley in 1922–1923 along the south side of the 3500 block of T Street. (Charles Volkman.)

IMAGES
of America

BURLEITH

Ross Schipper and Dwane Starlin

ARCADIA
PUBLISHING

Published by Arcadia Publishing
Charleston, South Carolina

Printed in the United States of America

Library of Congress Control Number: 2016958697

For all general information, please contact Arcadia Publishing:
Telephone 843-853-2070
Fax 843-853-0044
E-mail sales@arcadiapublishing.com
For customer service and orders:
Toll-Free 1-888-313-2665

Visit us on the Internet at www.arcadiapublishing.com

*To the many who have graced the streets
of this wonderful neighborhood.*

CONTENTS

ACKNOWLEDGMENTS

The authors would like to begin by giving thanks to those current and former residents and friends of Burleith who generously provided historical photographs for use in this book: in particular, Alfred Bigelow, Barbara Flynn, Bonnie Hardy, Charles and Jutta Volkman, Edgar Farr Russell III, Jack French, Jeffery King, Jerald Clark, Mara Viksnins, Mary Flynn, Mary Ann MacKensie, Marguerite Cunningham, Myles Johnson, Nancy Lensen-Tomasson, Sarah Revis, and Susan Lockwood.

Next, we would like to acknowledge Glover Park historian Carlton Fletcher, whose website www.gloverparkhistory.com contains a treasure trove of information regarding the early history of the land that would eventually become the Burleith neighborhood.

Western High School played an enormous role in the history of Burleith, and we are especially indebted to Anne Garnier, archivist for the Western High School Alumni Association, who provided access to historical data and images regarding that school and its Cadet Corps.

The archives of the Burleith Citizens' Association are held in the George Washington University, Gelman Library, Special Collections Research Center. That research center was an important source of historical photographs and data regarding Burleith. Other sources of photographs included the Kiplinger Library of the Historical Society of Washington, the Library of Congress, the National Library of Scotland, and the Peabody Room of the Georgetown Library.

The archives of the *Washington Evening Star* and the *Washington Post*, available in searchable form on the website of the District of Columbia library, www.dclibrary.org, have been important sources of information regarding Burleith's history.

The story of Burleith is alive and well, and its history is told not only in old photographs but also in new photographs of old objects. Thanks go to Linda Brooks and Jeannette Murphy, who assisted the authors by providing digital images to help document Burleith's historic fire call boxes.

This effort is a project of the Burleith History Group, many of whose members have helped in this effort. The authors would especially like to thank Carol Baume, Ed Ohl, Edgar Farr Russell III, Myles Johnson, Nicholas Gill, Patricia Scolaro, Perrin Radley, and Richard and Linda Hall for their assistance.

INTRODUCTION

Burleith is a small, quiet residential neighborhood in northwest Washington, DC, bounded on the south by Georgetown University on Reservoir Road, on the north by Whitehaven Park, and on the east and west by upper Georgetown and Hillandale respectively. Inside its boundary are 533 residential units, mostly row houses, and two educational institutions, the Duke Ellington School of the Arts (formerly Western High School) and the Washington International School's primary school campus. The Classical Revival building that housed Western High School opened its doors in 1898 and is listed in the National Register of Historic Places. Other than the Burleith Market, a small family-owned convenience shop that once was located on the corner of Thirty-Fifth and T Streets, Burleith has had no commercial enterprises. Thus, the history of Burleith is the history of its residential architecture, the history of the people who have lived in the community, and the history of the students who were educated here.

The majority of Burleith's row houses were built in the 1920s as part of the Shannon & Luchs Burleith development. The houses built by Shannon & Luchs are an adaptation of Georgian architecture and owe their design to W. Waverly Taylor Jr. and architect Arthur B. Heaton. The Shannon & Luchs Burleith development itself received national recognition when these houses were built between 1923 and 1928, and the influence of this development on contemporary architecture at that time was so strong that similar developments were made in Detroit, Baltimore, and Philadelphia. Other developers, such as the Cooley Brothers, were responsible for most of the remaining post-1923 development of Burleith.

There were other edifices, now gone, that once graced Burleith. Among these are the Cedars, the Burleith house, the House of the Good Shepherd, and the Convent of the Good Shephard. The Cedars was built in the early 1820s as the home of Georgetown mayor John Cox. Burleith, a two-story brick building erected after 1849, was the home of John Cox's son, Richard Smith Cox. The House of the Good Shepherd, built in 1890, was a home for "penitent" girls operated by a cloistered order of nuns. The Cedars once stood on the campus of the Duke Ellington School of the Arts, while Richard Cox's Burleith and the House of the Good Shepherd were located on the grounds of what is now the Washington International School.

For the most part, the children of Burleith were educated in three schools: the Fillmore School, Gordon Junior High School, and Western High School. The Fillmore School was built in 1893 and named in honor of US president Millard Fillmore. Gordon Junior High School was built in 1928, and the structure now houses the Rose L. Hardy Middle School. In 1898, Western High School moved into the building now occupied by the Duke Ellington School of the Arts. The Fillmore School and Gordon Junior High School lay along the east side of Thirty-Fifth Street just barely outside the current boundary of the Burleith neighborhood. The Western High School building, listed in the National Register of Historic Places, lies entirely within present-day Burleith.

The Western High School Cadet Corps, part of the Washington High School Cadets, played a pivotal role in training Burleith's youth to become good citizens and leaders. Many of the cadet corps' graduates went on to serve the United States in conflicts such as the Spanish-American War, World Wars I and II, and the Korean War.

In the early 1970s, Burleith's historic fire call boxes were stripped of their electronic innards and allowed to rust and decay. In 2013, the Burleith History Group, one of the special interest groups of the Burleith Citizens' Association, began an effort to restore these remnants of a system that, since the earliest days of Burleith, had alerted the fire department to emergencies in the neighborhood. A documentation of this effort is a fitting conclusion to a pictorial history of the Burleith neighborhood.

One

ORIGINS OF BURLEITH

In the 1950s, Edgar Russell Sr., the first historian of Burleith, developed a Burleith coat of arms. It is divided vertically: the left half depicts the flag of the District of Columbia; the right half, the flag of Maryland, because the present District of Columbia was formed from Maryland's territory. The name *Burleith* originated in Scotland, and the lion's head at the crest of the helmet represents Great Britain. (Edgar Farr Russell III.)

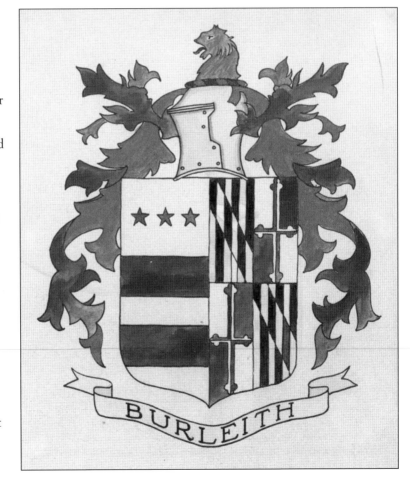

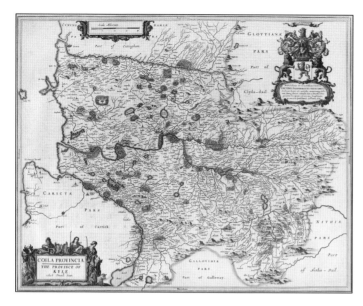

The name *Burleith* goes at least as far back as 17th-century Scotland. In 1711, Mathew Hopkins was born in Kilmarnock, Scotland. As a young man, Mathew immigrated to Maryland, then a British colony, and in 1742, he purchased two tracts of land. This 1654 Scottish map drawn by Timothy Pont (who lived from around 1560 to 1614) shows the province of Kyle, the area of Scotland where Mathew Hopkins was born. (National Library of Scotland.)

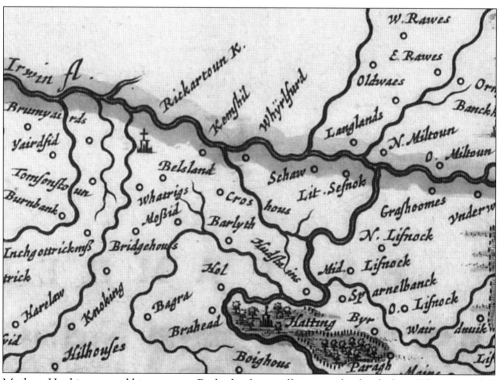

Mathew Hopkins named his property Berleith after a village near his birthplace. This expanded inset shows Barlyth at its center. This village near Kilmarnock appears in an 1890 map of Scotland with the spelling "Barleith" and in a 1950 map as Burleith. The name *Burleith*, or a variant thereof, was brought to North America and is the origin of the name of the Burleith neighborhood. (National Library of Scotland.)

After Mathew Hopkins died in January 1751, his widow, Mary, married Henry Threlkeld (1716–1781). Henry was born in Cumberland County, England. Henry eventually acquired Mathew's estate, Berleith, which bordered on the Potomac River. Georgetown University and the Georgetown Visitation Preparatory School are on part of his land. Like George Washington, Henry was a farmer. This miniature portrait bears an image of Henry Threlkeld. (Historical Society of Washington, Kiplinger Library.)

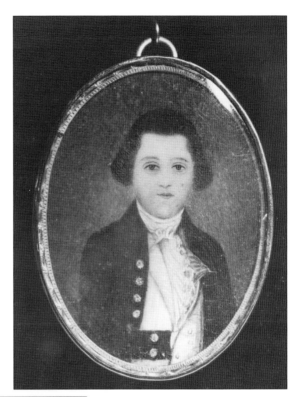

Henry and Mary Hopkins Threlkeld had one child, John Threlkeld (1757–1839), who became a leading citizen and eventually mayor of Georgetown. The property assembled by Henry and John Threlkeld was consolidated in 1791 and called Alliance. Alliance consisted of well over 1,000 acres and included what is now Georgetown University, the Georgetown Visitation Preparatory School, and several Washington neighborhoods, including Burleith. (Historical Society of Washington, Kiplinger Library.)

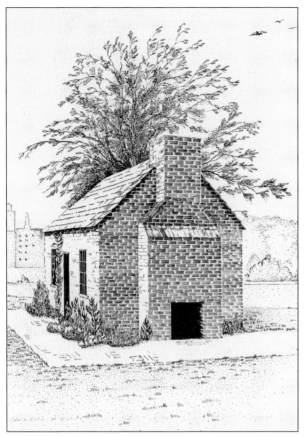

Henry Threlkeld's home, Burleith, sat on the grounds currently occupied by the Georgetown Visitation Preparatory School. Burleith was likely built in the 1740s after Mathew Hopkins immigrated to Maryland and purchased the land. Burleith burned shortly after the American Revolution and was later rebuilt. Today, the only remnant of the original Burleith estate is a small cabin. Originally a wooden structure, the cabin (pictured below in 2015) was later renovated and built in brick. A 1958 article in the *Washington Post* identifies this structure as the "Old Slave Quarters"; however, later research has discounted this. It was more likely used as a kitchen or a storage facility for the Burleith estate. Edgar Farr Russell Sr., the first historian of the Burleith community, created this ink drawing of the Threlkeld Cabin around 1955. (Left, Edgar Farr Russell III; below, photograph by Linda Brooks.)

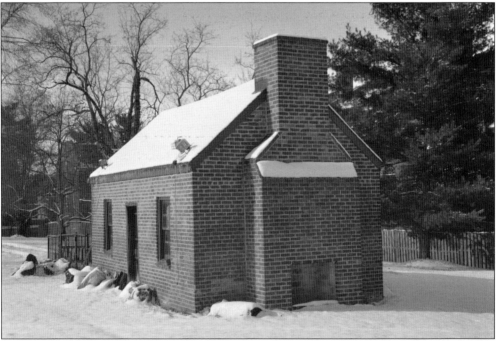

Mathew Hopkins —m1— Mary Brown —m2— Henry Threlkeld
(1711–) (1717–1801) (1716–1781)

Elizabeth Ridgely —m— John Threlkeld
 (1757–1830)

Jane Threlkeld —m2— John Cox —m1— Matilda Smith
(1795–1847) (1775–1849)

Richard Smith Cox
(1825–1889)

John Threlkeld's daughter Jane married John Cox, who already had a son, Richard Smith Cox, from a previous marriage to Matilda Smith. Jane brought a portion of the Threlkeld estate as a dowry to her husband, who built a home (the Cedars) where the Duke Ellington School of the Arts (formerly Western High School) now stands. The pedigree chart shows the relationship between Mathew Hopkins, who brought the name *Burleith* from Scotland, and Richard Smith Cox, who eventually brought that name to the neighborhood. The Cedars burned in 1847 and was later rebuilt by Richard Smith Cox. This is a view of the rebuilt Cedars. It was razed when Western High School was built in 1898. (Above, drawing by Ross Schipper; below, Historical Society of Washington, Kiplinger Library.)

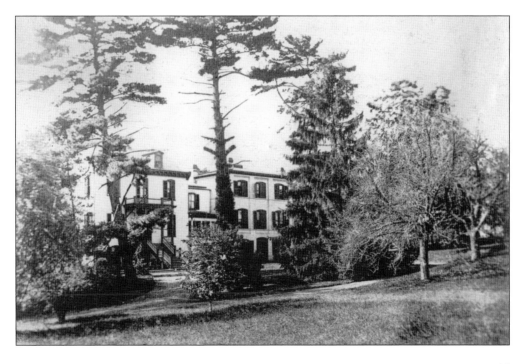

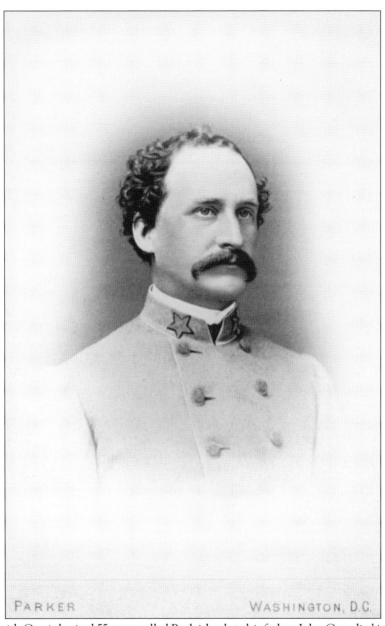

PARKER · WASHINGTON, D.C.

Richard Smith Cox inherited 55 acres called Burleith when his father, John Cox, died in 1849. The footprint of Richard's inheritance was very similar to that of the present-day Burleith neighborhood. Richard built a two-story brick home called Burleith, which stood on the block now housing the primary school campus of the Washington International School. The same block was the site of the House of the Good Shepherd and later the Convent of the Good Shepherd. None of these buildings exist today, as the Washington International School replaced them in 1998. Counting the original home of Henry Threlkeld, Burleith, and the Burleith that was rebuilt after the first one burned, Richard Smith Cox's Burleith was the third structure bearing that name. Richard Cox had Southern leanings and owned slaves. He left Washington, and his Burleith estate was confiscated during the Civil War. Richard Cox's property was eventually restored to him after the war, but he never returned to live in Burleith. (Georgetown Library, Peabody Room.)

In 1886, the Huidekoper family came into possession of Richard Smith Cox's Burleith tract, and in 1887, Frederic Huidekoper subdivided Burleith, calling it the Burleith Addition to West Washington. In this 1887 map of Huidekoper's subdivision, Richard Smith Cox's home Burleith is in block 133. The numbered streets correspond to their modern Burleith names, while U, V, and W Streets correspond to R and T Streets and Whitehaven Parkway. (*Washington Post.*)

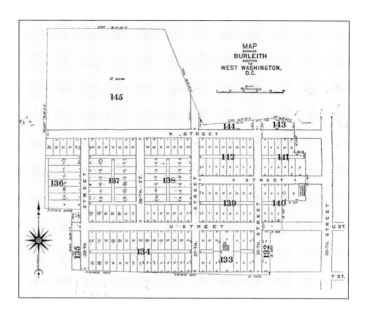

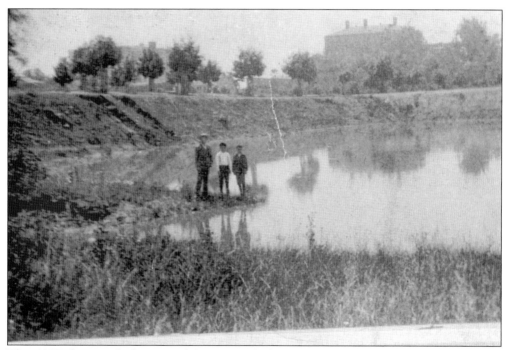

This 1907 photograph shows Huidekoper's Burleith in a view looking southward across a large pond. In the distance are the House of the Good Shepherd and Western High School, partially blocked by trees. The exact location of the pond is uncertain, but it is likely that Thirty-Seventh Street runs above the embankment to the left, so it was bounded roughly by Thirty-Seventh and Thirty-Eighth Streets and on its south by T Street. (Edgar Farr Russell III.)

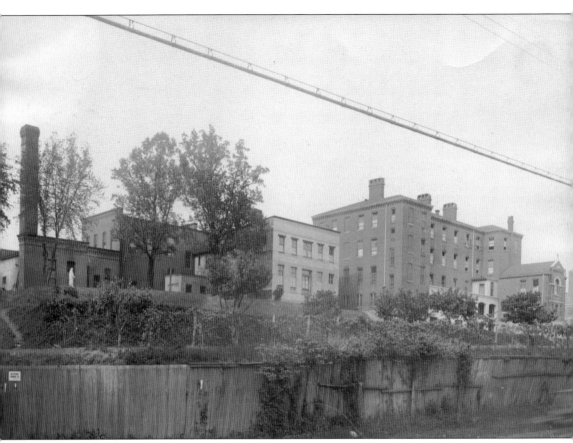

In 1887, all of block 133 shown in the Huidekoper map on page 15, including Richard Smith Cox's home Burleith, was purchased for the Sisters of the Good Shepherd, a cloistered order founded in France in 1641 that followed the Rule of St. Augustine. The House of the Good Shepherd afforded "a refuge to females who have had the misfortune to lead an evil life and who wish to abandon their vicious course and to reform their lives." The date 1890 on its main building is presumably the date that structure was erected. In this c. 1920 photograph, from left to right, are a commercial laundry and bakery with a tall smokestack, Cox's two-story home Burleith, and the main House of the Good Shepherd building. During this period, Cox's house, Burleith, served as a residence for the persons in charge of the House of the Good Shepherd. (Historical Society of Washington, Kiplinger Library.)

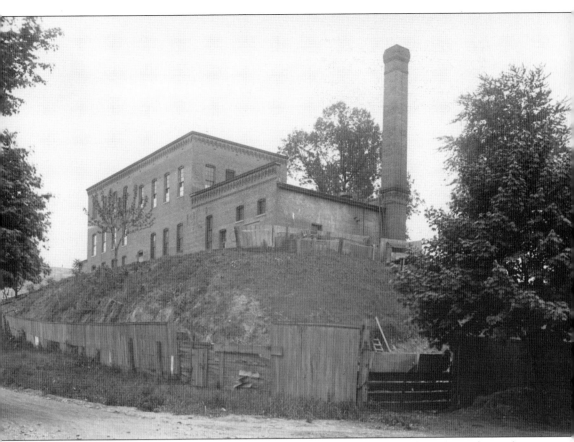

This 1925 view looking southeast from the corner of Thirty-Seventh and R Streets shows the commercial laundry and bakery with its tall smokestack. The bakery supplied the wafers used for Holy Communion for most of the Catholic churches in the area. The girls and women contained in the House of the Good Shepherd were taught needlework and later typing and other skills to help them earn a living after they were discharged. Burleith residents strongly opposed an effort to expand the House of the Good Shepherd in the late 1930s and again in 1952, when the institution desired to add a five-story dormitory to its campus. Burleith citizens were able to stop the proposed addition. They argued that it would exceed zoning height restrictions, that the laundry service was approaching "commercial proportions," that the smokestack was a source of odious black smoke, and that the institution, with "inmates" restrained behind a wire fence, was not appropriate for a residential, family-oriented community. (Historical Society of Washington, Kiplinger Library.)

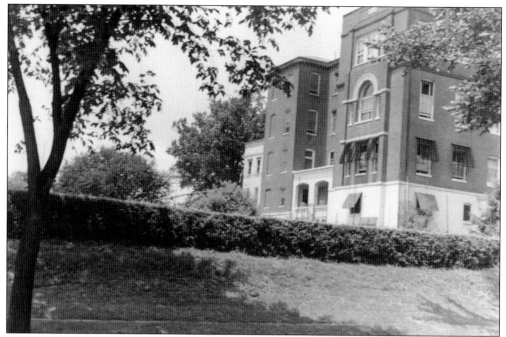

This view of the original main building of the House of the Good Shepherd was taken in June 1950 from Thirty-Sixth Street between Reservoir Road and R Street. Part of Richard Smith Cox's Burleith house peeks out from behind the farthest extension of the building. The laundry smokestack is not visible from this angle. (Historical Society of Washington, Kiplinger Library.)

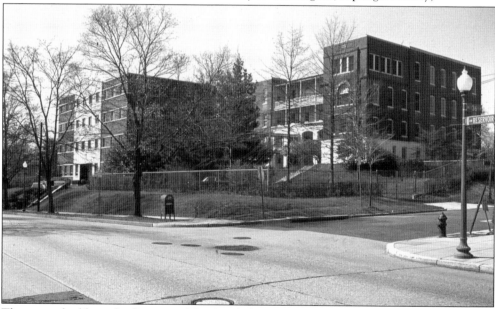

The newest building, the Convent of the Good Shepherd, was erected in 1954. In this April 1968 photograph taken from the corner of Reservoir Road and Thirty-Sixth Street, the convent is the building on the left facing Reservoir Road. The sisters from the House of the Good Shepherd moved into their newly constructed convent, leaving the original 1890 building as a school for the reeducation of delinquent girls. (Historical Society of Washington, Kiplinger Library.)

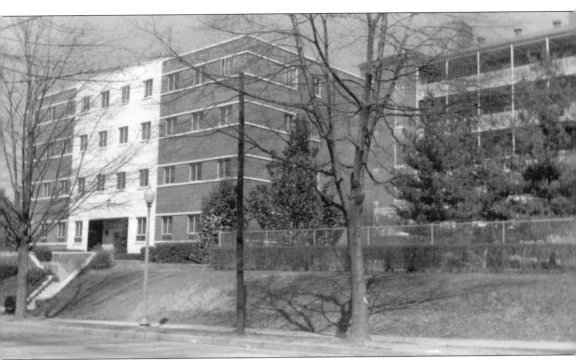

The House of the Good Shepherd, built in 1890, was used as a home for women and girls. Its "inmates" were penitents who came of their own accord or were consigned by parental or civil authorities. The penitents lived in the original House of the Good Shepherd building, seen on the right in this 1963 photograph. Three years later, in 1966, the institution housing the penitents began to be phased out. The sisters moved to a convent in Philadelphia. The House of the Good Shepherd was closed, and the girls were transferred to Baltimore. Major renovations of the original House of the Good Shepherd were begun in 1968. The top floor of the building was torn down, as was the adjoining laundry building, the smoke from which had prompted many complaints from Burleith residents over the years. In 1972, all the nuns moved into the convent building on the left in this photograph; this left the original 1890 House of the Good Shepherd ready for the next phase of its existence. (Edgar Farr Russell III.)

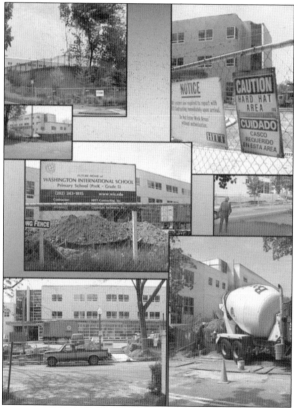

After 1981, the House of the Good Shepherd building remained essentially vacant for two years, until 1983, when, during a renovation of the Western High School building, the sisters rented two floors of the building to the Duke Ellington School of the Arts. In 1984, the two remaining floors were rented to the Levine School of Music. Levine stayed in the building until 1992. The August 1997 photograph above shows the Levine School of Music sign still over the R Street entrance to the building. The House of the Good Shepherd and the Convent of the Good Shepherd were razed to make way for the primary school campus of the Washington International School, which opened in 1998. The image at left is a collage created in April 1998 by Joseph Golian, showing scenes from the construction of the Washington International School. (Above, Charles Volkman; left, Bonnie Hardy.)

Two

Early Burleith Development

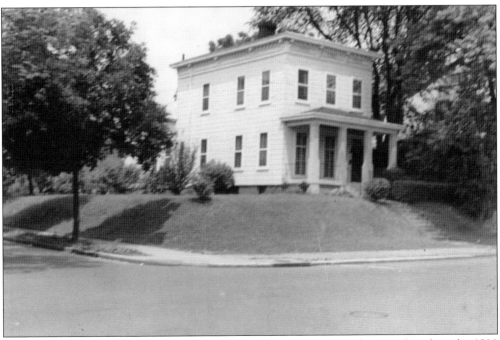

Burleith's oldest homes lie on Thirty-Fifth Street (Fayette Street in the 1800s) and on the 3500 blocks of S and T Streets and Whitehaven Parkway. This picture, taken in June 1950, shows 1704 Thirty-Fifth Street, built in 1919. At the time of this photograph, this house was the closest to the northwest corner of Thirty-Fifth and R Streets. In 1965, another house was built between this one and R Street. (Historical Society of Washington, Kiplinger Library.)

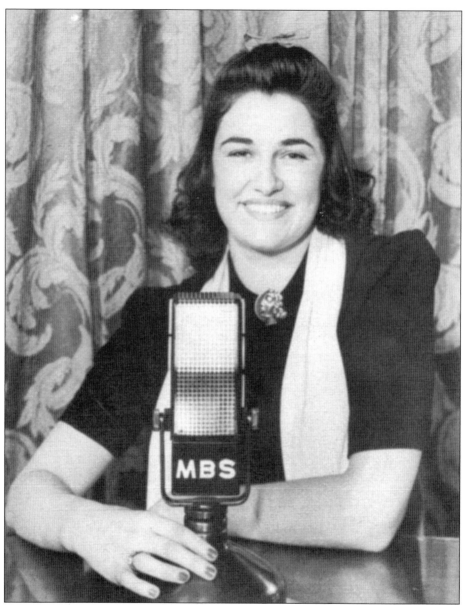

This April 1941 image shows Nancy Ordway (1914–2005), who played the leading role in the radio series *Helen Holden, Government Girl*, a nationally broadcast program. Ordway lived in Burleith at 1710 Thirty-Fifth Street, a domicile that is still known as the Ordway House. In a 2004 letter to Jack French, Ordway recalls an episode in one radio program: Helen Holden was at the Shoreham Blue Room, being toasted with champagne, when the propman, on cue, slammed two glasses together (it was supposed to be a gentle clink). To cover this shock, Ordway laughingly said, "Skoal!" Her role was supposed to be that of a small-town girl from the Midwest, and there were snickers all over the studio. Frances Brunt eventually replaced Ordway in the Helen Holden role. In 2004, John Kelly reported in the *Washington Post*, "Even though the show was on radio, not television, the producer eventually decided the lead actress needed to look more glamorous for publicity photos." However, it is believed that Burleith's nationally broadcast radio star was very glamorous indeed. (Jack French.)

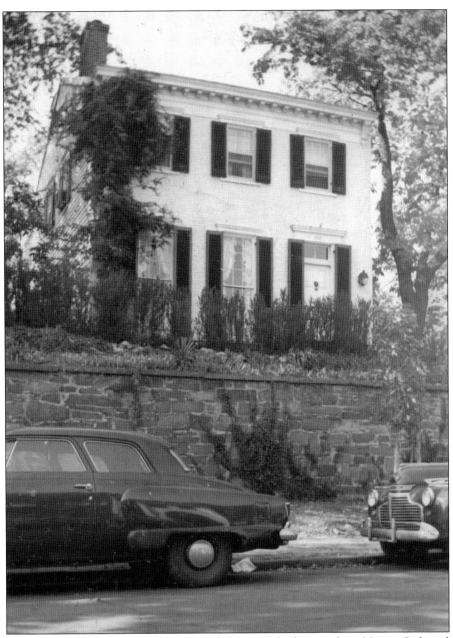

This 1950s photograph shows 1710 Thirty-Fifth Street, the house where Nancy Ordway lived. A structure on this site dates to 1860, when it first appeared in the Georgetown directory as 191 Fayette Street, the home of Arthur Schott, a civil engineer. In 1930, Nancy's father, Col. Godwin Ordway, purchased the site and had the house rebuilt under the auspices of architect Arthur B. Heaton. Colonel Ordway was the son of Albert Ordway (1843–1897), who joined the Union army as a private in 1861 and rose to the rank of colonel by 1865. For his war services, he was brevetted with the rank of brigadier general. After the war, General Ordway was the organizer of the District of Columbia National Guard and commanded the brigade from its earliest days to the time of his death in 1897. In April 1905, Omaha Street in Cleveland Park was renamed Ordway Street in his honor. (Edgar Farr Russell III.)

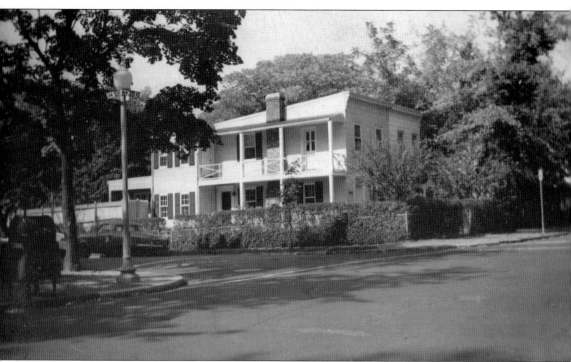

This photograph taken around 1950 shows the house at 1800 Thirty-Fifth Street, built in 1900, that sits on the northwest corner of Thirty-Fifth and S Streets. There is a persistent neighborhood legend that there was at one time a tavern or farmhouse located on this site, and that Pres. Thomas Jefferson met with Meriwether Lewis at that tavern in 1803. It was supposedly Lewis's last stop before setting out on the Lewis and Clark Expedition crossing the newly acquired Louisiana Purchase to the West Coast. Although there has been no independent confirmation of this meeting or even of the existence of a tavern, it makes a good story. Of the current homes in Burleith, the only one that was in existence in 1803 was 1812 Thirty-Fifth Street, just a few houses to the north of this one. (Edgar Farr Russell III.)

These three homes along Thirty-Fifth Street in this late-1950s photograph all predate the Shannon & Luchs development that began in 1923. Starting from the left, the first of these, 1810 Thirty-Fifth Street, was built in 1894, shortly after the acquisition of the Burleith tract by Frederic Huidekoper in 1886. The second, 1812 Thirty-Fifth Street, was built earlier in 1820, almost 30 years before Richard Smith Cox inherited the Burleith tract upon the death of his father, John Cox, in 1849. It had been the tiniest house in the area, consisting of only two rooms, until a recent addition considerably expanded the rear of the house. The white house on the right, 1814 Thirty-Fifth Street, is the oldest existing structure in Burleith, having been built in 1803 during the presidency of Thomas Jefferson. Indeed, it is one of the oldest houses in Washington, DC. (Edgar Farr Russell III.)

The 1940s photograph at left, taken by Iris Beatty Johnson of 3829 S Street in Burleith, shows a streetcar heading south on Wisconsin Avenue. It is passing the Little Flower Shop at 1256 Wisconsin Avenue, whose sign is seen on the left. Coke Homan, a Burleith resident, who lived at 1914 Thirty-Fifth Street, was the very flamboyant owner of the Little Flower Shop. Homan died in 1983. The current structure at 1914 Thirty-Fifth Street was built in 1984, so Homan must have lived in a previous structure at that site. The 1945 photograph below shows Barbara Andrews in front of the house next door at 1912 Thirty-Fifth Street. Her family lived in that house from 1941 to 1950. That house was also razed, and a new one was built to replace it. (Left, Myles Johnson; below, Barbara [née Andrews] Flynn.)

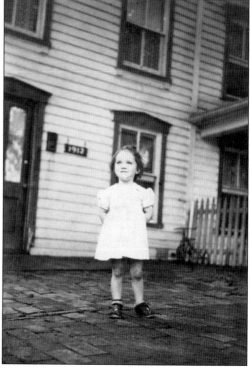

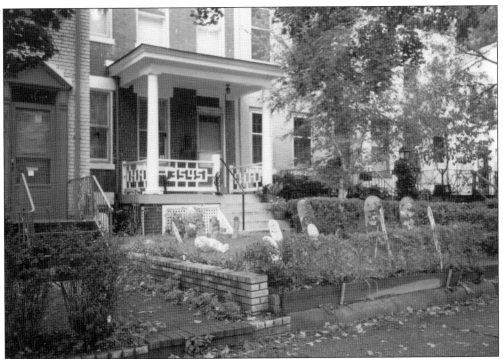

The undated photograph above shows 3545 S Street decorated for Halloween. Of the over 530 homes in Burleith, this house built in 1912 is one of only 71 that were built before the Shannon & Luchs Burleith development began with its ground breaking in March 1923. In 1955, Dr. Harold M. Elwyn, then owner of Western Pharmacy—for many years a landmark on the northeast corner of Thirty-Fifth Street and Reservoir Road—created a neighborhood Halloween party in the parking lot behind the pharmacy. This traditional Halloween celebration for the children of Burleith continues to this day, but it has since moved to the tot lot at the Fillmore School near the corner of Thirty-Fifth and S Streets. The July 1965 photograph below shows the Western Pharmacy. (Above, Sarah Revis; below, Historical Society of Washington, Kiplinger Library.)

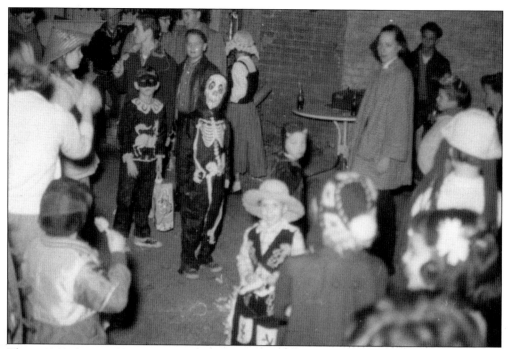

The c. 1960 photograph above shows a Halloween party at the Western Pharmacy. The Western Pharmacy was located at 1665 Thirty-Fifth Street in a white building on the northeast corner of Thirty-Fifth Street and Reservoir Road, built about the time of the Civil War. The c. 1927 sketch below shows the building that would house the pharmacy on the left. On December 8, 1925, that building would have suddenly found itself in Burleith. It was on that day that the Burleith Citizens' Association voted to move the eastern boundary of Burleith from Thirty-Fifth Street to Wisconsin Avenue. In June 1947, Dr. Harold M. Elwyn opened the Western Pharmacy, and in 1955, he—along with the Burleith Citizens' Association—created the annual neighborhood Halloween party in the parking lot behind the pharmacy. (Above, Edgar Farr Russell, III; below, Burleith Archives.)

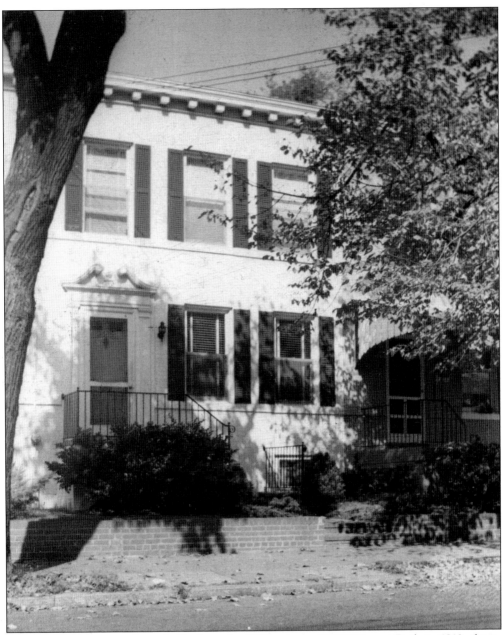

This undated photograph, probably from the 1950s, shows 3505 T Street. Built in 1910, this is another of the pre–Shannon & Luchs domiciles. Two doors down from this house is 3509 T Street, for which, in January 2001, Mia Hamm, soccer celebrity and star forward on the then new women's professional soccer team, Washington Freedom, put down a rental deposit. Both of these houses along T Street are in a section of Burleith known as Bryantown. The origin of that name is uncertain. In the 1930s and 1940s, young children played on Whitehaven Park and the extensive wooded area behind it that connected with Archbold Park. This led to the Chesapeake & Ohio (C&O) Canal and the Potomac River. The children called the Whitehaven Park forest the "BT Woods." Perhaps this meant the "Big Timber Woods" or the "Bryantown Woods." No one knew for sure—it was just the BT Woods. (Edgar Farr Russell III.)

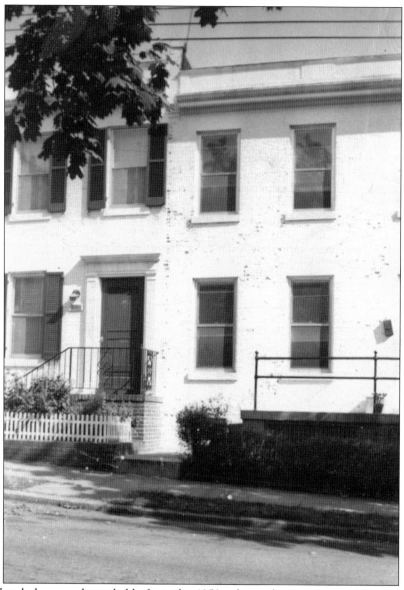

This undated photograph, probably from the 1950s, shows the entrance to 1911 Thirty-Fifth Place. Built in 1916, this and other houses along Thirty-Fifth Place also belong to the section of Burleith known as Bryantown. At one time, Thirty-Fifth Place, only a block long, was known as "Incubator Row," because there were so many young children living there. Across the street from this house is 1908 Thirty-Fifth Place. After having rented 1924 Thirty-Fifth Place since the fall of 1937, Metropolitan Police sergeant Walter Roy Ostrom and his wife, Elvira, purchased 1908 Thirty-Fifth Place in 1940, and four generations of the Ostrom family have resided there. A crawl space beneath the Ostrom house revealed brick foundations of a previous building. Probably extending under the two adjacent houses, it may have been part of an original farm building. During World War II, their son Jack Ostrom served in the 4th Marine Regiment in the Pacific. He was wounded at Corregidor and spent months in captivity in Cabanatuan, a Japanese prison camp on Luzon. He was finally rescued on January 30, 1945, in the Great Raid at Cabanatuan. (Edgar Farr Russell III.)

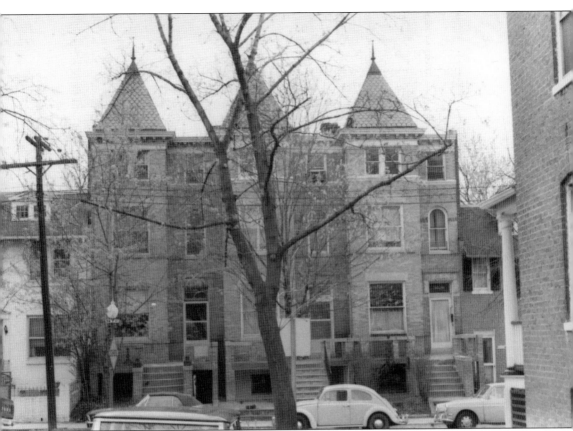

The three elegant homes in this 1968 photograph—3526, 3528, and 3530 T Street—were built around 1905 for Frederick W. Huidekoper by builders Allard & Appelby. They were sold as part of the Huidekoper estate in 1908. At one time, Lt. Horace Lake lived in 3528 T Street. In September 1918, Lieutenant Lake flew over the Hindenburg line during the Battle of Saint-Mihiel and attacked German emplacements. As is the case with all communities, the residents of Burleith have not always experienced joy and heroism, but have also had occasional measures of tragedy. In 1934, four-year-old Bunky Campbell lived at 3530 T Street. Bunky's "closest pal," Sgt. Ernest Walton, lived at 3517 T Street. In June 1934, apparently incorrectly fearing a demotion, Sergeant Walton took his own life by turning on all the burners of his gas stove. When little four-year-old Bunky was told of his hero's death, he was reported to have said, "Aw, he's jus' sick. He'll come back. We're pals." What a sad day for little Bunky. (Jerald Clark.)

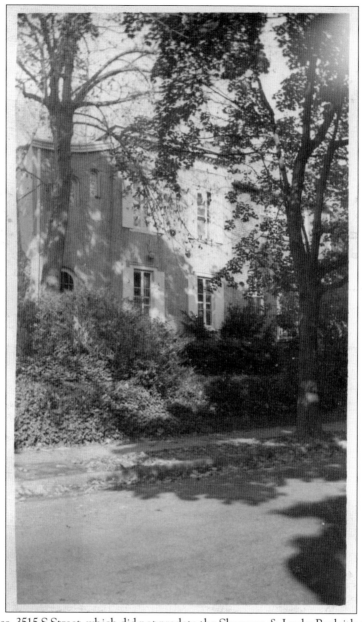

Another house, 3515 S Street, which did not predate the Shannon & Luchs Burleith development, perhaps deserves special attention here and appears in this photograph that dates to the 1950s. When it was built in 1927, it was advertised as "True Spanish." In the back, it had a beautiful garden and terraces secluded by walls. Its neighbor at 3513 S Street was also built in 1927. Neither is a Shannon & Luchs home, although the pair is surrounded on both sides by Shannon & Luchs row houses built in 1924. In August 1951, Corp. Dan D. Mayers, son of Shirley D. and Evelyn Mayers of 3513 S Street, was serving in Korea when he coached a red-bellied frog named Morphine Mary, who became the "celebrated jumping frog" of a 2nd Division aid station in Korea when she leaped to victory a lunge or so ahead of her closest competitor, Jellybean. This did not occur in Calaveras County, but Mark Twain might have enjoyed Corporal Mayers and his frog anyway. (Edgar Farr Russell III.)

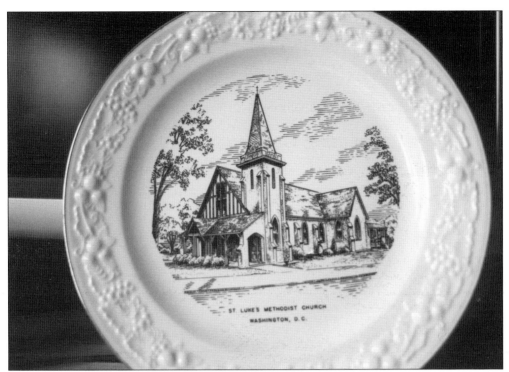

During 1933 and 1934, the Burleith Citizens' Association held its monthly meetings at the Mount Tabor Church on Thirty-Fifth Street. Built in 1874, the church was known in its early years as the Butcher's Chapel, because it served the butchers and cattle drovers who herded their cattle down High Street, now Wisconsin Avenue. In 1946, the congregations of three churches merged to form St. Luke's, but they continued to use the church building until 1954. The pre-1954 plate at the top contains an image of St. Luke's before the move. In 1956, the Divine Science Church, a Christian metaphysical denomination, moved into the building as it now appears in the image below and that congregation continues to lease the space from the National Park Service. (Both, Charles Volkman.)

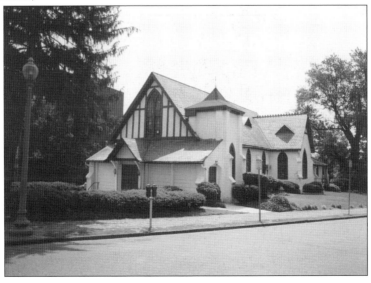

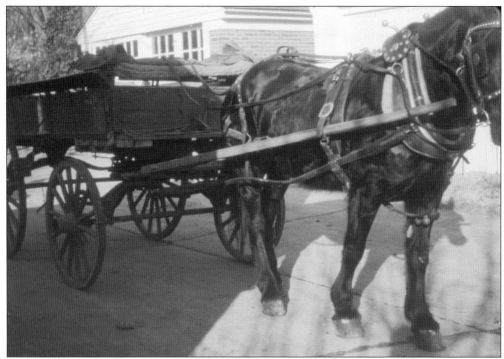

The early 1940s photographs above by Iris Beatty Johnson shows the horse and cart of a junkman who would periodically come through the alleys of Georgetown and Burleith. Long recognized as providing a vital industry in European nations, junkmen were sometimes known as rag and bone men; an old cart, bells and a horse, such as this one, symbolized the junkman in the United States. Things began to change in the fall of 1941. The increase in production by American defense industries was forcing stockpiles of scrap at steel mills to decrease at an alarming rate. As a result, junk collection became increasingly necessary to keep civilian plants running, and waste dealers began to accept a place of honor in the national defense spotlight. The c. 1900 photograph below shows another junk dealer. (Above, Myles Johnson; below, Historical Society of Washington, Kiplinger Library.)

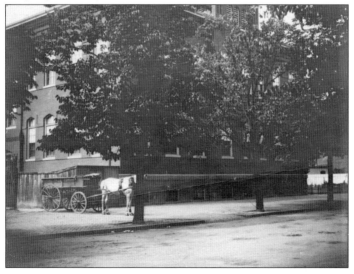

Three

THE SHANNON & LUCHS BURLEITH DEVELOPMENT

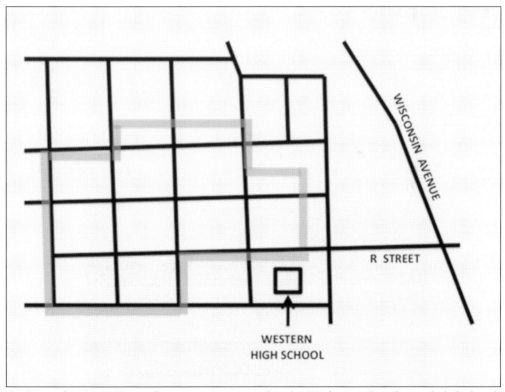

On December 16, 1923, an advertisement appeared in the *Washington Post* that included a hand-drawn map showing prospective buyers how to navigate to a new development by the builder Shannon & Luchs called Burleith. The diagram here is a facsimile of a portion of that map showing, in gray outline, the boundaries of the Shannon & Luchs Burleith development in the context of today's Burleith neighborhood. (Diagram by Ross Schipper.)

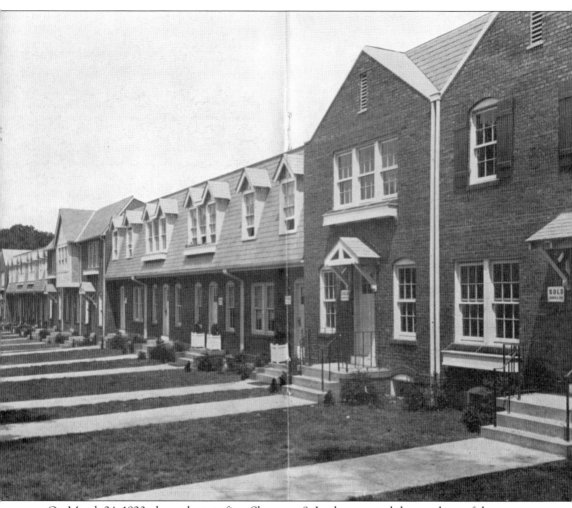

On March 24, 1923, the real estate firm Shannon & Luchs reported the purchase of the property holdings of Frederic L. and Reginald S. Huidekoper known as Burleith. Located near Georgetown, the property included about 10 city blocks of land lying north and west of Western High School. Frederic W. Huidekoper, father of the owners, originally laid out and subdivided Burleith. The development came under the direct supervision of architect Arthur B. Heaton, who developed the general architectural study of the development in order to avoid any conflict of design. This image appears in a 1923 Shannon & Luchs sales brochure and shows the homes on the south side of the 3600 block of T Street in a view looking southeast from Thirty-Fifth Street. These homes were among the first built by Shannon & Luchs as part of the Burleith development. The bilateral symmetry with a home on one side of the middle being an exact mirror image of the home on the other side of the middle is typical of the Burleith development. (Alfred Bigelow.)

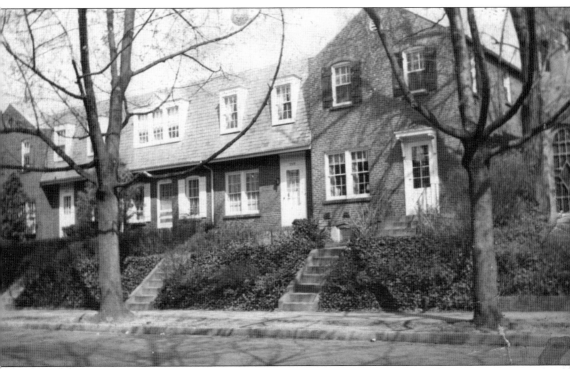

This segment of five row houses built in 1924 is a good example of the bilateral symmetry across the center typical of the Burleith development. The front facades of the end units with peaked roofs are exact mirror images of each other. The home on the left, 3525 S Street, has its entrance door on the left while its match, 3517 S Street, his its entrance door on the right. The front facades of the next pair, 3523 and 3519 S Street, are again mirror images. The house in the center, 3521 S Street, is the mirror image of itself. Mrs. M.G. McCarthy, grandniece of "Mountain Man" Thomas Fitzpatrick, lived at 3521 S Street. Cadet lieutenant colonel Robert Irons, who lived at 3523 S Street, led the 4th Regiment of Western High School's cadets to first place in the 1941 regimental competition. (Edgar Farr Russell III.)

This advertisement by Shannon & Luchs for Burleith homes appears in the June 23, 1923, *Washington Evening Star*. Given today's real estate prices, it is sometimes hard to believe that housing prices could have ever been so low. The first refrigerator to see widespread use was a General Electric model introduced in 1927, so home refrigerators were still a rarity in 1923, and as a result, the Burleith houses had built-in iceboxes. Nonetheless, the Burleith homes were very modern for their time and price. Many of Washington's neighborhoods were once segregated, and Burleith was no exception. According to a Shannon & Luchs brochure, one aspect of the Burleith development was the introduction of "helpful restrictions" into the deeds of the homes and the purchase contracts to maintain value and protect the buyers. This was a veiled reference to racially restrictive covenants attached to the deeds. A 1948 US Supreme Court decision finally put an end to such restrictive covenants. (*Washington Evening Star.*)

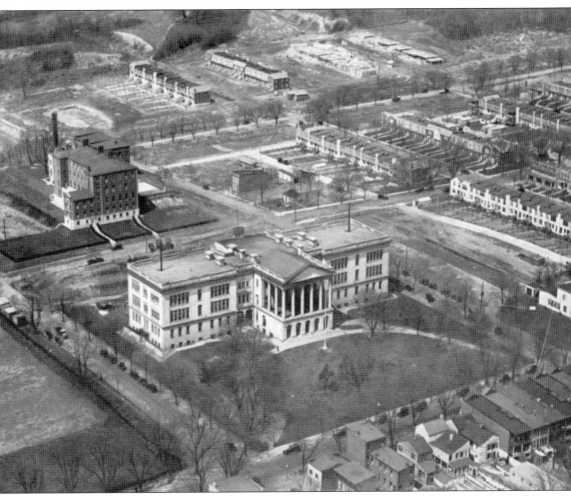

This aerial image showing early stages of the Burleith development appears in the 1924 yearbook of Western High School. Prominent in the foreground, the high school educated Burleith's children from the development's first residents until 1974, when it became the Duke Ellington School of the Arts at Western High School. Behind the high school sits the House of the Good Shepherd. Partially visible behind that building is a light-colored two-story building, the original Burleith residence of Richard Smith Cox. The tree-lined street angling upward near the top of the image is Thirty-Seventh Street. The Burleith houses along that street were not built until later. At the bottom of the image is the intersection of Reservoir Road and Thirty-Fifth Street. Parallel to Reservoir on the other side of the high school is R Street. Near where R Street intersects Thirty-Seventh Street is what appears to be a small pond. Settling after this pond was filled may have had a role in the partial sinking of a fire call box that sits on the northwest corner of that intersection. (Anne Garnier, archivist, Western High School Alumni Association.)

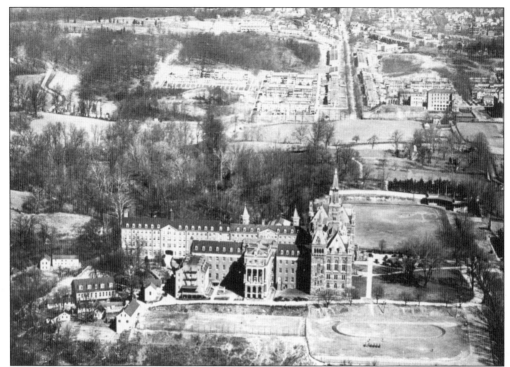

Another aerial photograph, this March 1927 image shows the Burleith development behind the Georgetown University's Healy Hall in the foreground. In the upper-right corner is the House of the Good Shepherd with Richard Smith Cox's Burleith just to its left. North of the spire of Healy Hall is Thirty-Seventh Street, and the Burleith houses along that street have now been built. (George Washington University, Gelman Library, Special Collections Research Center.)

The row house in the center of this photograph, taken in the winter of 1935, is 3705 Reservoir Road, which was, at that time, the home of Edgar Farr Russell Sr., his wife, Ida Rebecca (née Frazier) Russell, and their son Edgar Jr. The houses along Reservoir Road were built in 1928 and were the last houses built as part of the Shannon & Luchs Burleith development. (Edgar Farr Russell III.)

BURLEITH

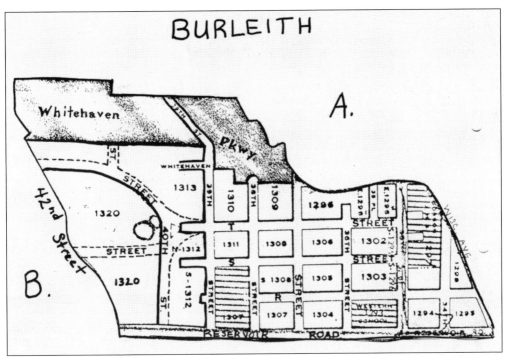

The Burleith Citizens' Association was founded on January 29, 1925, and its first president was Maj. John B. Richardson, who served for only three months, from January to March 1925. He was succeeded by John D. Battle of 3726 S Street, who served until March 1927. In those days, the members of the association met monthly. At the monthly meeting in December 1925, the Burleith Citizens' Association voted to reaffirm the boundaries originally established in January 1925 as follows: Wisconsin Avenue, Reservoir Road, Thirty-Ninth Street, and W Street. The undated map above from the Burleith archives shows the extended boundaries of the Burleith neighborhood. Below, a map that appeared in the *Washington Post* in 1940 shows the area served by the Burleith Citizens' Association still extending eastward to Wisconsin Avenue, a boundary confirmed by longtime Burleith residents. (Above, Burleith Archives; below, *Washington Post*.)

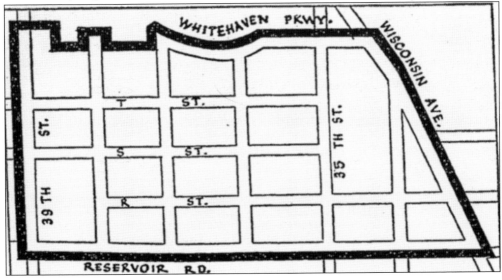

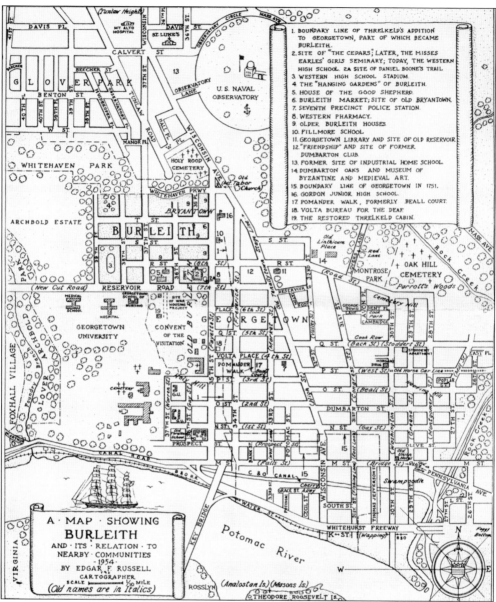

A · MAP · SHOWING
BURLEITH
AND · ITS · RELATION · TO
NEARBY · COMMUNITIES
- 1954 -
BY EDGAR F. RUSSELL
CARTOGRAPHER
SCALE ⊢⊢⊢⊢⊢⊢ ¹/₁₀ MILE
(Old names are in Italics)

1. BOUNDARY LINE OF THRELKELD'S ADDITION TO GEORGETOWN, PART OF WHICH BECAME BURLEITH.
2. SITE OF "THE CEDARS", LATER, THE MISSES EARLES' GIRLS SEMINARY; TODAY, THE WESTERN HIGH SCHOOL. 2A SITE OF DANIEL BOONE'S TRAIL.
3. WESTERN HIGH SCHOOL STADIUM.
4. THE "HANGING GARDENS" OF BURLEITH.
5. HOUSE OF THE GOOD SHEPHERD.
6. BURLEITH MARKET; SITE OF OLD BRYANTOWN.
7. SEVENTH PRECINCT POLICE STATION.
8. WESTERN PHARMACY.
9. OLDER BURLEITH HOUSES.
10. FILLMORE SCHOOL.
11. GEORGETOWN LIBRARY AND SITE OF OLD RESERVOIR.
12. "FRIENDSHIP" AND SITE OF FORMER DUMBARTON CLUB.
13. FORMER SITE OF INDUSTRIAL HOME SCHOOL.
14. DUMBARTON OAKS AND MUSEUM OF BYZANTINE AND MEDIEVAL ART.
15. BOUNDARY LINE OF GEORGETOWN IN 1751.
16. GORDON JUNIOR HIGH SCHOOL.
17. POMANDER WALK, FORMERLY BEALL COURT.
18. VOLTA BUREAU FOR THE DEAF.
19. THE RESTORED THRELKELD CABIN.

Edgar Farr Russell Sr., the first historian of Burleith, drew this map dated 1954. By that time, the Burleith neighborhood had assumed its current boundaries: Reservoir Road, Thirty-Fifth Street, Whitehaven Parkway, and Thirty-Ninth Street. It is unknown when the Burleith Citizens' Association decided that "East Burleith," bounded by Thirty-Fifth Street, Reservoir Road, and Wisconsin Avenue, was no longer under its purview; it must have been sometime between 1940 and 1954. On April 19, 1925, the Burleith Citizens' Association went on record in favor of the purchase by the District of the square bounded by Reservoir Road, Thirty-Sixth Street, R Street, and 100 feet west of the Thirty-Seventh Street as a location for an athletic field and stadium for Western High School. It was not until December 4, 1929, that the District finally appropriated money for the construction of the Western High School stadium at a different site. The map also shows the Western High School stadium in the two-city block area bounded by Reservoir Road and Thirty-Eighth, Thirty-Ninth, and S Streets. (Edgar Farr Russell III.)

The remaining images of the Shannon & Luchs Burleith development are presented in chronological order. This 1942 photograph by Iris Beatty Johnson shows the 3800 block of S Street. The house on the end, at 3835 S Street, was the home of R. Bruce Horsfall and his wife, Elizabeth. He was an illustrator for *Nature* magazine and internationally famous for his wild animal and bird drawings. (Myles Johnson.)

This 1946 photograph shows the rear view of R Street houses, looking northwest, between Thirty-Seventh and Thirty-Eighth Streets. These homes were built in 1925 and 1926. As was typical in the early days of Burleith, almost every house had a garage. In addition, in the days before air-conditioning, awnings were very popular. (Edgar Farr Russell III.)

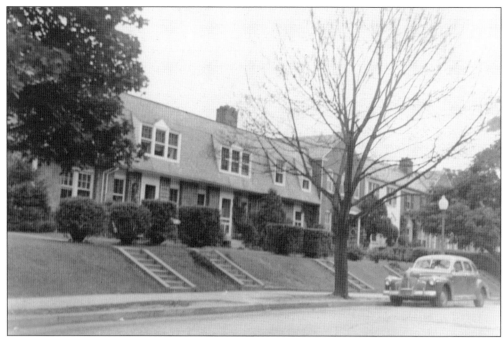

John P. Wymer took these photographs in June 1950. The image above shows houses built in 1925 on the north side of the 3500 block of R Street. The house with the peaked roof behind the tree is 3529 R Street. At one time, it was the home of Emil Sandsten, a native of Nybro, Sweden, whose experiments led to the development of new strains of vegetables suitable for high-altitude farming. The image below shows houses on the 3500 block of S Street. The steps lead up to the entrances of 3538 and 3540 S Street. Partially obstructed by trees is the front facade of 3542 S Street with its peaked roof. (Historical Society of Washington, Kiplinger Library.)

The view in this 1957 photograph looks south on Thirty-Seventh Street toward the intersection with S Street. The house on the left is 1803 Thirty-Seventh Street, built in 1925; the one on the right is 3636 S Street, built in 1924. Across the street is 1804 Thirty-Seventh Street, the home of Maj. Gen. Lindsay M. Silvester. General Silvester commanded the 7th US Armored Division for a time during the Battle of the Bulge. (Edgar Farr Russell III.)

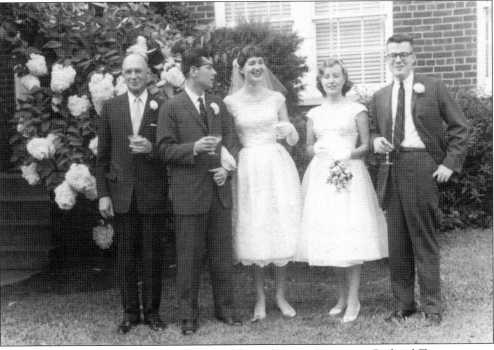

This August 1958 photograph from the wedding of Nancy Lensen to Richard Tomasson was taken in front of 3541 R Street. Nancy, the daughter of Walter G. and Kathryn Lensen, graduated from Western High School and won a scholarship to Wellesley College in 1949. She graduated from Wellesley in July 1953. From left to right are Walter G. Lensen, Richard Tomasson, Nancy Lensen, Carolina Harris (maid of honor), and Robert Tomasson (Richard's brother and best man). (Nancy Lensen-Tomasson.)

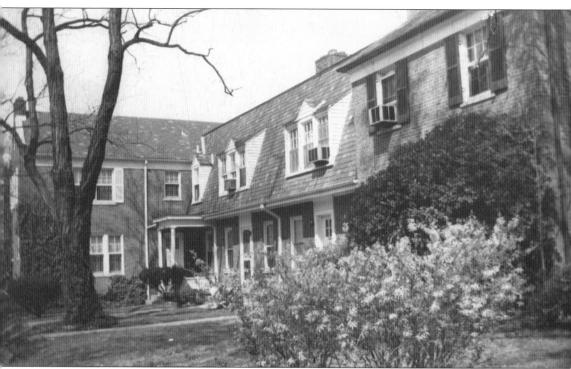

This photograph, taken in the spring of 1959, shows the northwest corner of the intersection of R and Thirty-Sixth Streets. The house that sticks out from the others is 3607 R Street, followed to the right by 3605 and 3603 R and 1700 Thirty-Sixth Streets. In 1936, Lois Kemp, an 11-year-old, won a court battle to allow the enrollment of nonresident pupils in District schools. Her father, John S. Kemp, worked for the Works Progress Administration and lived in Clarendon. Lois was the only one of his four daughters who was banned from District schools under the nonresident clause of the school laws. Lois graduated from Fillmore School in 1935 but was not allowed to enter Gordon Junior High School, even though her older sisters were admitted to Western High School and her younger sister to Fillmore. Ann Robinson Luce of 3607 R Street tutored Lois during the court fight. (Edgar Farr Russell III.)

Taken in 1960, the photograph above shows, from right to left, 3731, 3733, and 3735 R Street. Beyond 3735 R Street is the north cottage of the Western High School stadium. These Burleith row houses were built in 1926. The image below, also taken in 1960, shows Reservoir Road near the intersection with Thirty-Seventh Street. These houses were built in 1928 and were among the last houses constructed by Shannon & Luchs as part of the Burleith development. The rightmost of these houses is 1600 37th Street, at one time the home of Capt. Irvin W Carpenter. A US marine in World War I, he reentered the service as a naval officer in May 1941, just before Pearl Harbor. The House of the Good Shepherd looms in the background on the right. (Both, Edgar Farr Russell III.)

This photograph, taken in 1961, shows the back side of 3601 and 3603 S Street, across the alley between S and T Streets. Both houses were built in 1923. Above the peaked roof of 3603 S Street is the outline of the House of the Good Shepherd building. A small part of Richard Smith Cox's Burleith house is barely visible, just to the right of the House of the Good Shepherd. The property at 3601 S Street was the home of Elton Young, a real estate agent for Shannon & Luchs. On May 16, 1958, he received a color television set with a card from Shannon & Luchs to remind him that it was exactly 40 years since he joined that Washington realty firm. At 3603 S Street was the home of Vladimir Gsovski, chief of the European Law Division, Law Library, Library of Congress, and professor at Georgetown University's School of Foreign Service. Born in Moscow, Gsovski was an officer in the Russian Imperial Guard during World War I. (Jeffery King.)

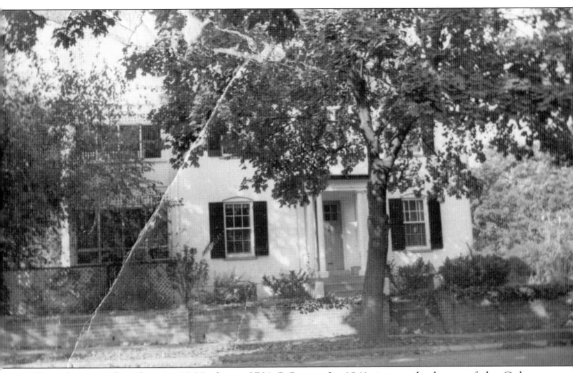

This photograph, taken in 1966, shows 3701 S Street. In 1941, it was the home of the Col. Ralph Bishop family. That year, June Norris Bishop, Colonel Bishop's seven-year-old daughter, a second-grade pupil at the Fillmore School, complained of a sore throat after returning from playing a part in a school Christmas play. Early the next morning, she began gasping for air. Calls were made to police, the rescue squad, and the emergency hospital. The rescue squad was dispatched, but arrived late because the address was thought to be 3701 F Street instead of S Street. June suffocated and died of laryngeal edema, a swelling of the larynx. Her parents and two sisters—Bonnie, a student at Gordon Junior High School, and Mardalee, a student at Vassar College—survived her. Colonel Bishop was executive secretary of the Civilian Military Education Fund. (Edgar Farr Russell III.)

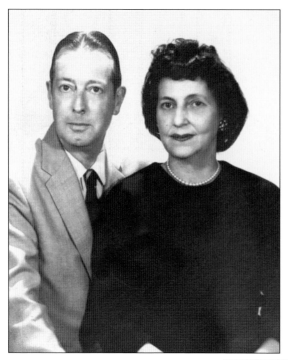

The Burleith Citizens' Association has represented the interests of the citizens of the neighborhood since its founding in 1925. In January of that year, Maj. John B. Richardson was elected the first president of the association. However, he resigned three months later. The 24th president was Edgar Farr Russell Sr., shown in the photograph on the left with his wife, Ida Frazier Russell. He served from May 1960 through December 1961. For most of its history, the Burleith Citizens' Association held monthly meetings of its membership. In 1967, under the leadership of then president Lt. Col. Robert B. Curtiss, 70 percent of the approximately 530 families in Burleith were members of the association. The 36th president, Mary Ann MacKensie, is shown in the 1980 photograph below. (Left, Edgar Farr Russell, III; below, Mary Ann MacKensie.)

Proof that Burleith has had a permanent attraction for its residents is demonstrated by this example where children, and then grandchildren, of Burleith residents have made their homes here. This spring 1972 photograph shows three generations of Russells. To the left are Edgar Farr Russell Sr. and his wife, Ida Frazier Russell. A first family of Burleith, they purchased their newly built Shannon & Luchs home at 3705 Reservoir Road in 1928. Edgar Sr. was the first Burleith historian, writing the small book *A Brief History of Burleith* published in July 1955 and again in May 1973. He also served as the president of the Burleith Citizens' Association from May 1960 to December 1961. To the right are their son Capt. Edgar Farr Russell Jr., USN; their grandsons Edgar Farr Russell III and Frazier Neely Southey Russell; and Capt. Russell's wife, Jean Peake Russell. In 1954, Edgar Jr. and Jean bought another Shannon & Luchs home at 3721 Reservoir Road. Their son Edgar III still lives in Burleith. (Edgar Farr Russell III.)

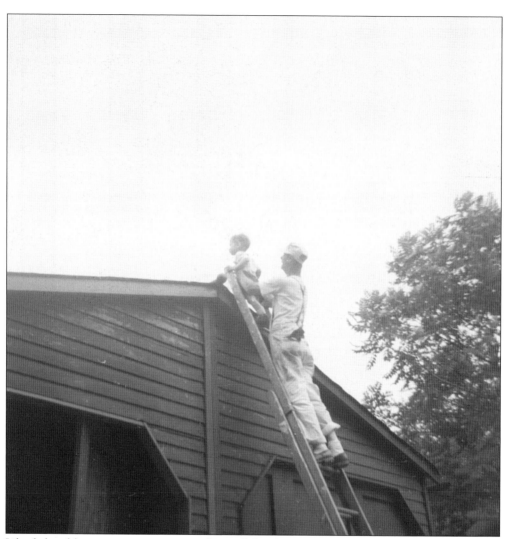

Like father, like son: two generations of Russell family boys got themselves into unpremeditated predicaments. The first, concerning two-year-old Edgar Jr., is recounted in a February 1930 *Washington Evening Star* article written by his aunt Corinne Frazier Gillette. Corinne, a White House reporter assigned to Eleanor Roosevelt, was the sister of Ida Frazier Russell, the mother of Edgar Jr., who found the key to his parent's bedroom door fascinating. Turning the key, he locked himself in. Ida tried to open the door and, after an hour, called police. Officer Edward La Force of the Seventh Precinct rescued him by using a ladder to climb through the second-floor window. Twenty-seven years later, Edgar Jr.'s three-year-old son, Edgar, III, decided to climb a ladder to visit his friend, local Burleith neighborhood handyman Roy Harper, who was working on the family's roof. Harper was shocked when Edgar peered over the top rung and quickly brought him back down. This late-1950s image of Harper holding him, gazing over the garage, reminds Edgar of that unforgettable day. (Edgar Farr Russell III.)

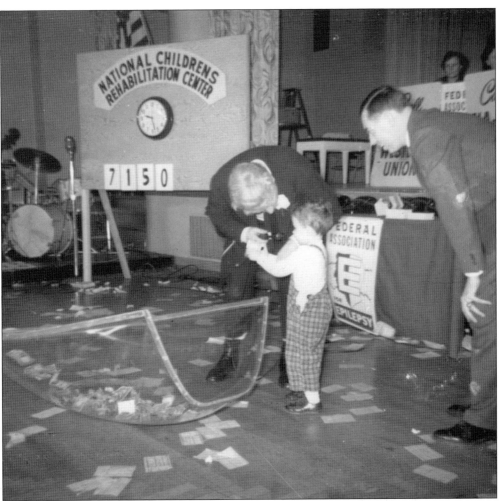

In the evening of February 9, 1957, WTTG Channel 5 and radio WOL 1450 presented, at the Shoreham Hotel, a star-studded show for the National Children's Rehabilitation Center, a project of the Federal Association for Epilepsy, Inc. The show included stars such as Jimmy Ray Dean and Steve Lawrence, but in this 1957 photograph, Edgar Farr Russell Jr. introduces his son Edgar III to the boy's biggest star: none other than Captain Kangaroo (Bob Keeshan). Young Edgar asked the captain if he could play the drums seen in the background, but the children's television star said that they were not his drums, so he could not give permission. Keeshan portrayed the original Clarabell the Clown on *The Howdy Doody Show*, but he was most well-known for his weekday-morning *Captain Kangaroo* show that aired on CBS for nearly 30 years, from October 3, 1955, until December 8, 1984. (Edgar Farr Russell III.)

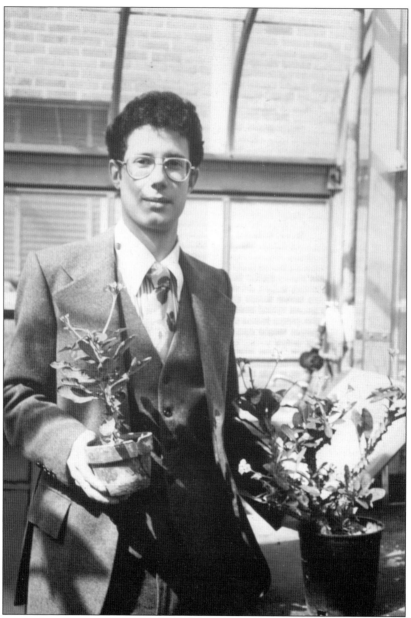

This photograph, taken in fall 1975, shows Edgar Farr Russell III, age 21, in his senior year at Georgetown University. He is standing in the university's botany greenhouse holding two *Euphorbia splendens* plants he grew from cuttings as part of his biology major senior thesis. This plant species, also known as Crown of Thorns, was introduced to the Middle East in ancient times. Edgar III later gave one plant to his parents, Edgar Jr. and Jean Russell, who kept it growing in their home for more than 20 years. Edgar III retired as a lieutenant colonel in the US Air Force and is now an award-winning writer, director, and actor whose work has appeared on National Public Radio, television, and the stage. He is a past president of the Lincoln Group of the District of Columbia and also the Metropolitan Washington Old Time Radio Club. Currently, he serves as the president of the Washington, DC, chapter of the National Society of Arts and Letters. (Edgar Farr Russell III.)

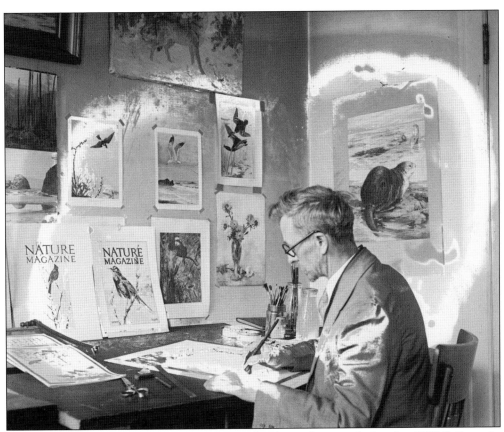

Robert Bruce Horsfall (1869–1948), shown in the above photograph, lived at 3829 S Street in Burleith. An internationally known wildlife and nature illustrator, he worked with the American Museum of Natural History, the Peabody Museum of Natural History, and the US National Museum and was affiliated with the paleontological department at Princeton University. He was director of arts for *Nature* magazine and a researcher and artist for the Smithsonian Institution. He traveled to study the natural environment of animals and birds of many countries, painted backdrops, and set up the zoological and botanical divisions of the Smithsonian Institution. Horsfall also painted background scenes for the National Zoo. One of his works appears below. (Both, Library of Congress.)

Iris Beatty Johnson was a well-known illustrator of children's books. Among the best known were her illustrations of the Ginnie and Geneva series written by Catherine Woolley. Originally published in 1948, the series eventually consisted of 10 volumes. Iris and her husband, Wynne Johnson, were a first family of the Shannon & Luchs Burleith development, having been the first owners of 3829 S Street, built in 1927. They had two sons, Humphrey and Myles. In 1957, Humphrey published a book titled *The Perilous Journey*, illustrated by his mother. Humphrey served as an associate editor at *Jack and Jill* magazine. In this Easter 1942 photograph, Iris stands on the front steps of 3835 S Street, the home of her neighbors Robert Bruce Horsfall and his wife, Elizabeth. On Thursday, July 27, 1944, Elizabeth Horsfall disappeared from her home. On August 1, two Georgetown University dental students found her body in a wooded area less than 100 yards from her home. (Myles Johnson.)

Myles Johnson was born and grew up in Burleith at 3829 S Street. His parents, Wynne and Iris Beatty Johnson, were a first family of the Burleith development, having been the original residents of that newly built Shannon & Luchs property, They bought it in 1926 for approximately $9,000. Myles lived there from his birth in 1929 until he married in 1952. His mother continued to live at 3829 S Street until she moved to nursing care in 1975. Taken in the spring of 1945, this photograph of Myles as a teenager shows him standing over the fence in the backyard of his next-door neighbor at 3831 S Street in Burleith. Myles attended Fillmore Elementary School, Gordon Junior High School, and Western High School. He is still active in the Western High School Alumni Association and was once the archivist for that organization. (Myles Johnson.)

This late 1950s photograph shows 3834 T Street sitting on the southeast corner of the intersection of Thirty-Ninth and T Streets. This Shannon & Luchs row house was built in 1926 and was the home of W. Waverly Taylor Jr. Waverly Taylor, a builder and architect, was a principal architect of the Shannon & Luchs Burleith development along with Arthur B. Heaton. He was also one of Washington's most eligible bachelors when, in March 1949, the Baron Henry Snoy of Brussels and his wife, the Baroness Corina Snoy, announced his engagement to their daughter Edmée Rose Marie Ghislaine. The marriage took place on April 21 of that year in Brussels. In November 1956, while living in their Burleith home, Edmee Taylor became a naturalized American citizen in ceremonies in district court. So, the Burleith neighborhood can add a European aristocrat to the many famous personages who have lived here. (Edgar Farr Russell III.)

In this October 1967 photograph, George Viksnins poses with his three children in front of his Shannon & Luchs home at 3731 T Street, built in 1924. On the left is Ingrid (in the clown costume), and on the right is Helen, his elder daughter. He is holding Peter, the youngest, who was almost one year old at the time. (Mara Viksnins.)

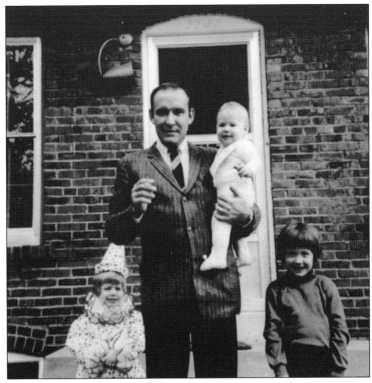

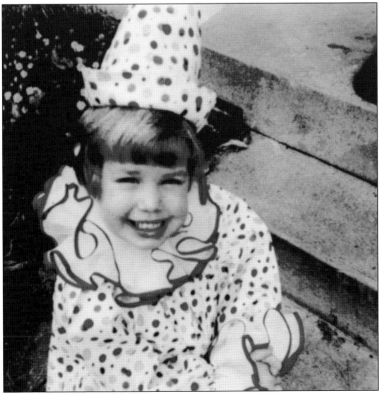

George's wife, Mara Viksnins, sewed Ingrid's Halloween costume using yards and yards of ruffles. Those were the days before permanent press and the cotton had to be starched and ironed. Their fourth child, Brigit was born in 1970. Mara used to sew matching jumpers for the girls, but when Brigit was about two years old, she declared her individuality and said that if her mother was allowed to wear pants, she should be able to wear them, too. (Mara Viksnins.)

The Burleith Garden Club was founded in April 1926 and played an important part in the development of the neighborhood for almost 75 years until it was disbanded around 2000. This January 1972 photograph, with a view looking southeastward, shows the south side of the 3800 block of T Street. In October 1930, Dr. George Roth, a pharmacologist and rose expert residing at 3814 T Street, won an award from the garden club for the best yards (front and back) in Burleith. Honorable mention went to Paulyne Hann of 3828 T Street. Dr. Roth was the chairman of the Department of Pharmacology at George Washington University for more than 20 years and retired in 1945. An avid rosarian, he won many ribbons in Potomac Rose Society shows. Also on the subject of flowers: in the spirit of National Flower Week, starting on October 28, 1956, Paul Pitcher, age nine, of 3818 T Street, a patrol boy at Fillmore School, got a posy from Mary Banks, age eight, of 3533 R Street. (George Washington University, Gelman Library, Special Collections Research Center.)

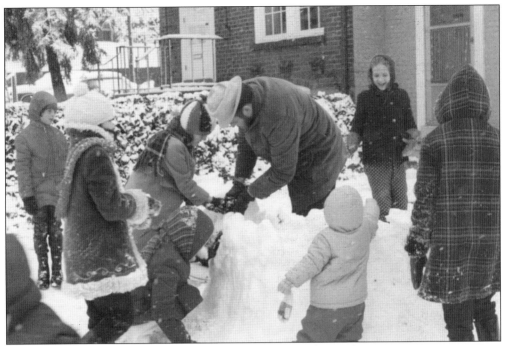

On Sunday, February 20, 1972, Pres. Richard Nixon arrived in China, and a heavy winter storm dumped nearly a foot of snow on the Washington area, cutting off electricity to thousands. Snow removal crews worked to clear roads from the storm that began early the previous day, as gusts of wind undid their work as fast as they could clear the snow away. To the children of Burleith, neither geopolitics nor the weather could get in the way of just having fun, as is clear in these two photographs. Above, George Viksnins of 3731 T Street assists Burleith children in the building of a snow fort in front of 3733 T Street. (Both, Mara Viksnins.)

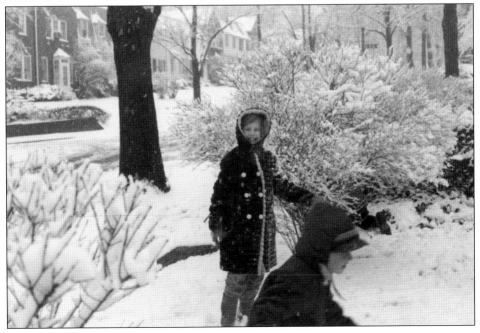

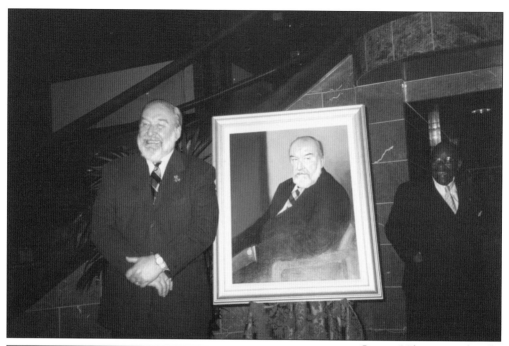

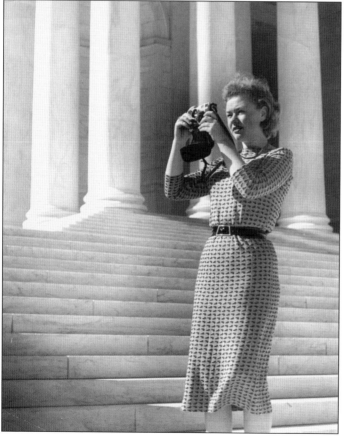

George Viksnins, as briefly mentioned on the previous page, was a Georgetown University professor of economics. The George Viksnins Scholarship Fund was established in 2002 to honor Professor Viksnins for his more than 30 years of service to the Fund for American Studies (TFAS). The 2002 image above shows Viksnins next to his portrait, which was unveiled at the Walter Judd Freedom Award ceremony, where he was the award recipient and honoree. The portrait now hangs in TFAS headquarters. His wife, Mara Karulis Viksnins, who immigrated from Latvia, has been a lifelong photographer. The 1957 image at left shows Mara and her camera in front of the Lincoln Memorial. (Both, Mara Viksnins.)

Four

THE COMPLETION OF BURLEITH'S DEVELOPMENT

This June 1950 photograph shows houses built along the north side of the 3800 block of T Street. Between 1926 and 1931, the Cooley Brothers built over 60 homes, including these, in several phases. The remaining Burleith homes were the result of smaller developments. In 1939, Muhleman & Kayhoe built 12 homes designed by Arthur L. Anderson on Thirty-Ninth Street; and Paul D. Crandall built 30 structures on Whitehaven Parkway. (Historical Society of Washington, Kiplinger Library.)

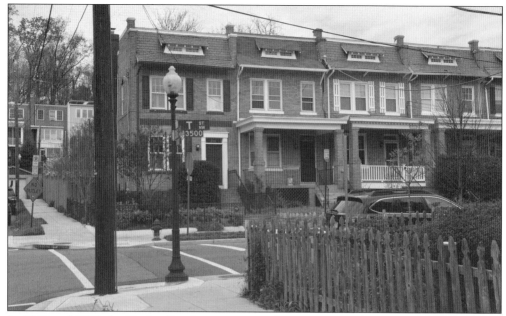

In 1926 and 1927, the Cooley Brothers constructed seventeen row houses on Thirty-Seventh Street south of Whitehaven Parkway and these on the north side of T Street east of Thirty-Sixth Street. The leftmost house, 3541 T Street, was the home of Brig. Gen. Herbert C. Holdridge, the only US Army general to retire during World War II. In January 1948, he ran for the Democratic nomination for president. (Photograph by Linda Brooks.)

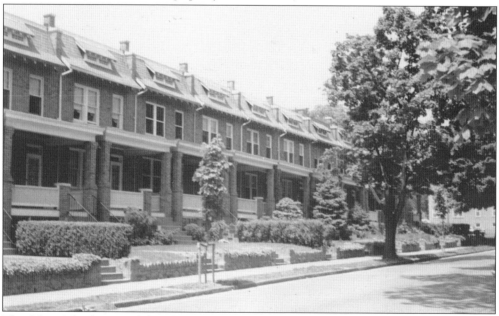

This May 1951 photograph by John Wymer shows Cooley Brothers homes on the west side of Thirty-Seventh Street just south of the intersection with Whitehaven Parkway. The leftmost steps lead up to 1920 Thirty-Seventh Street, one-time home of Harry Fox who worked for the phone company at Walter Reed Hospital where he was famous for going the extra mile to help patients connect with loved ones. (Historical Society of Washington, Kiplinger Library.)

This October 1950 photograph by John Wymer shows homes on the 1900 block of Thirty-Eighth Street built by the Cooley Brothers between 1929 and 1931. In November 1944, 2nd Lt. James Matthews of 1929 Thirty-Eighth Street received the Distinguished Flying Cross for piloting troop carriers supporting Marshal Tito's partisans in the Balkans. Landing often at night on improvised airfields deep within enemy territory, he flew over 65 missions. (Historical Society of Washington, Kiplinger Library.)

In 1931, the Cooley Brothers built these half-timbered homes in an adaptation of Elizabethan English architecture on the north side of the 3800 block of T Street, as shown in this June 1950 photograph by John Wymer. The builder called these and the Cooley Brothers homes on Thirty-Eighth Street "Burleith Heights." With their steeply pitched roofs, these homes are truly impressive. (Historical Society of Washington, Kiplinger Library.)

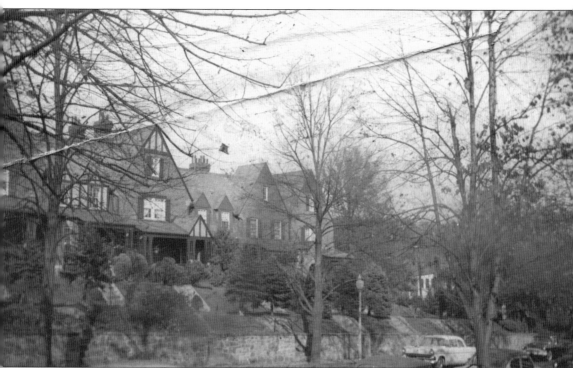

This c. 1950 photograph of the Cooley Brothers homes was taken in the winter. With the leaves off the trees, it is easier to grasp the magnificent architecture of these homes. The house at the end was the home of Lt. Col. Robert B. Curtiss. In 1967, he was completing his fourth and final term as president of the Burleith Citizens' Association. Under his leadership, the association's membership reached 350, or nearly 70 percent, of the slightly over 530 homes in Burleith. Colonel Curtiss championed a variety of programs designed to keep the Burleith neighborhood vital. One of his projects was finding and establishing a place for preschool children to play. He believed that a neighborhood dies and decays unless one continually brings young blood into it, especially young couples with children. However, the search for a "tot lot" ran up against a problem when many older residents who had lived in Burleith since its early days quarreled with young parents over where or if such a playground should be located. (Edgar Farr Russell III.)

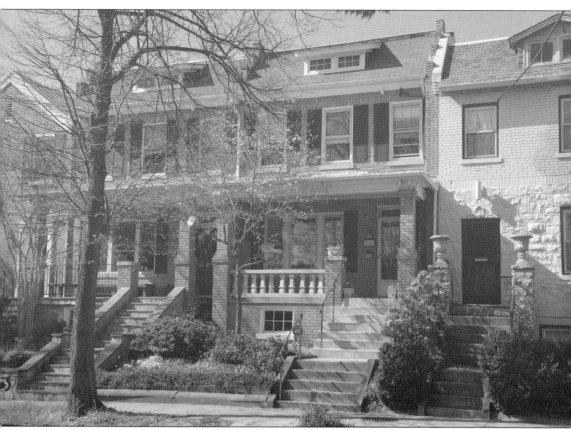

Harry Wardman (1872–1938) was a real estate developer responsible for developing huge swaths of Northwest DC. Busy throughout the first few decades of the 20th century, Wardman arguably made a bigger impact on the district's residential real estate scene than any other developer. In some neighborhoods, such as Woodley Park, Wardman row houses are well regarded for their fine features and protected by preservation rules. Nonetheless, the only Wardman structures in Burleith, both built in 1926, are these two row houses at 3607 and 3609 T Street. These homes sold for $11,750 in 1926 and included the wide front porches, sleeping porches in the back, and concrete block garages. In 1929, the year of the stock market crash, 3609 T Street was the residence of S. Deering Emery, a baker, who had to declare bankruptcy, when he was unable to meet his liabilities. (Photograph by Linda Brooks.)

The October 1951 image above, by John Wymer, shows a group of five homes numbered 1931 through 1939 Thirty-Ninth Street that were designed by architect Arthur L. Anderson (1893–1980) and built in 1940 by Muhleman & Kayhoe, Inc. of Richmond, Virginia. Born in Boston, Anderson moved to Washington in 1933 and became a very prominent architect, designing numerous residential and commercial properties until his retirement in 1965. One of his major projects was the Prince Georges Plaza shopping center. In 1968, three more houses, numbered 1925, 1927, and 1929 Thirty-Ninth Street, were built on the southern end of the Muhleman & Kayhoe development. The autumn 1956 image below was taken before this additional construction, which would have covered the skyline defined by the roofs of Cooley Brothers homes in background on the right. (Above, Historical Society of Washington, Kiplinger Library; below, Edgar Farr Russell III.)

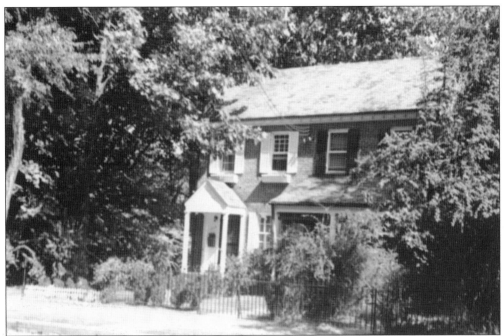

On Thirty-Ninth Street, just north of the 1940 Muhleman & Kayhoe development, is another development of 12 row houses, numbered 1941 to 1963. They were built a year earlier in 1939, also by Muhleman and Kayhoe. In addition, their architect was again Arthur L. Anderson. The above October 1950 image by John Wymer shows 1963 Thirty-Ninth Street, the northernmost unit in this development. To the left of this house is Whitehaven Park. Part of the Rock Creek Park system, Whitehaven Park stretches from Thirty-Fifth Street to Glover-Archbold Park and forms the northern boundary of the Burleith neighborhood. This parkland was a favorite haunt for Burleith's children. The c. 1945 image below shows four Burleith boys getting ready to skate on Foundry Branch, a creek that runs through Glover-Archbold Park. (Above, Historical Society of Washington, Kiplinger Library; below, Myles Johnson.)

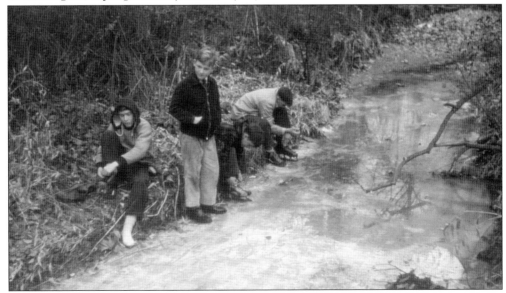

Builder Paul D. Crandall erected these two houses with adjacent front doors on Whitehaven Parkway in 1939. Part of a development that stretched all the way to Thirty-Seventh Street, they are 3530 and 3532 Whitehaven Parkway. The structure that sticks out just past the tree is, in fact, a pair of homes—3526 and 3528 Whitehaven Parkway, also built in 1939 by Paul Crandall. In September 1943, during World War II, Pfc. George E. Corbin Jr. of 3528 Whitehaven Parkway went overseas and was wounded in action in France during the D-day invasion. The property at 3530 Whitehaven was the home of Lyle T. Shannon. During a 22-year military career, he rose from the rank of private to colonel in the Army. He was awarded the Legion of Merit and the French Croix de Guerre. Shannon joined the CIA in 1946, where he was awarded that agency's Intelligence Medal of Merit. (Edgar Farr Russell III.)

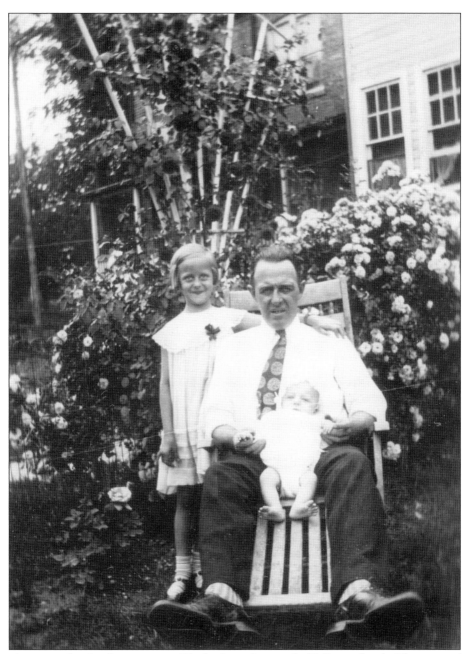

Another example of multigenerational Burleith residents is the Volkman family. There were three Charles Volkmans in the family: Charles Volkman Sr., Charles H. Volkman, and Charles Volkman, also known as "Charlie." It was Charles H. who first moved into Burleith. He and his Swedish wife, Anna, bought their house at 3548 T Street in 1926. The home was designed by architect William P. Cissel and built in 1923. This picture, taken in 1931, shows Charles H. with his baby son Charlie and daughter Anna Corinne, age seven, in the backyard of their home. Charles H. was a veteran of World War I, having enlisted in the Naval Reserves in June 1917. His son Charlie now lives in the family home on T Street with his wife, Jutta. (Charles Volkman.)

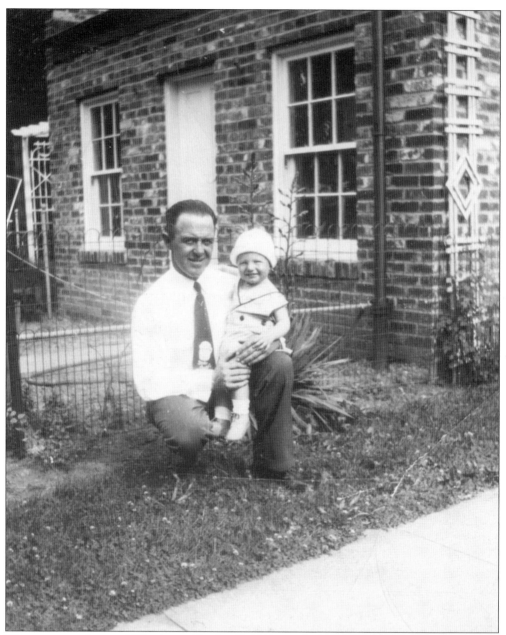

This picture, taken in 1932, shows Charles H. Volkman holding his by then one-year-old son Charlie on his knee. Volkman's tie sports a beer mug with a healthy head of foam—German beer no doubt. Charles H. was a chauffeur for a private family and a member of the Private Chauffeurs Benevolent Association of Washington, DC. In February 1938, he helped organize a "chauffeurs' night out" party at the Raleigh Hotel for the members of the association. The hotel opened in 1893 on the northeast corner of Twelfth Street and Pennsylvania Avenue NW and was demolished in 1964. A list of the employers of the chauffeurs present at the 1938 Private Chauffeurs Benevolent Association party would have included some of the most influential members of Washington society, including Pres. Franklin D. Roosevelt and First Lady Eleanor Roosevelt. (Charles Volkman.)

These two photographs, the first taken in 1949 and the second in 1950, show Charlie Volkman. Charlie was born in Burleith, and the photograph at right shows him in his Western High School cadet uniform. Like so many of the cadets, Charlie joined the military after graduating from Western High School. The photograph below shows Charlie in his US Marine Corps uniform, standing proudly on the corner of Thirty-Sixth and T Streets in Burleith. Charlie was also a Boy Scout. After the first snow of the winter of 1946, Charlie saw that the sidewalk of his neighbor was not shoveled. Being true to the Boy Scout slogan, "Do a Good Turn Daily," Charlie proceeded to shovel his neighbor's walk. The *Washington Evening Star* reported that Charlie refused payment, saying, "You don't owe me anything. I'm a Boy Scout." (Both, Charles Volkman.)

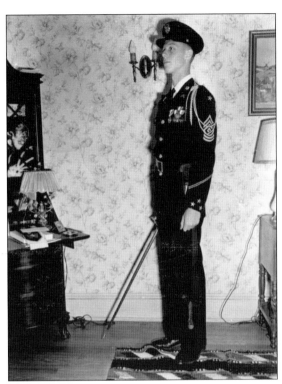

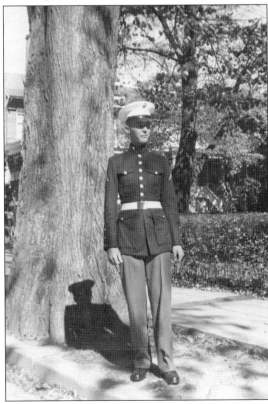

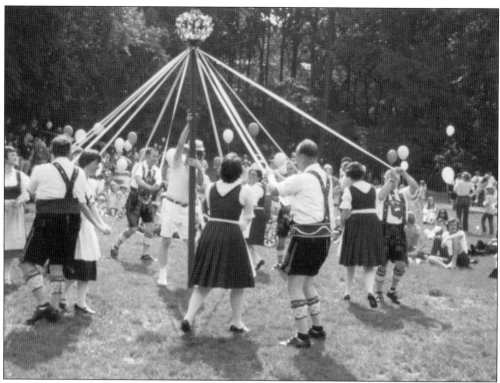

Starting in 1971, the Burleith Citizens' Association has held a summer picnic in the green lot of Whitehaven Park at the corner of Thirty-Seventh Street and Whitehaven Parkway. Since 1973 was the 50th anniversary of the ground breaking for the Shannon & Luchs Burleith development, the 1973 picnic was one of the largest. This June 1973 picture shows Charlie and Jutta Volkman of 3548 T Street, along with other members of the Washingtonia Bavarian Dance Club, performing German folk dances at that picnic. Charles Volkman Sr., Charlie Volkman's grandfather, was a member of the Georgetown Schuetzen Verein, a shooting club founded by German Americans that functioned as a social club for the community. In September 1869, the Georgetown Schuetzen Verein held its inaugural first celebration in Georgetown, with Charles Volkman Sr. a member of the executive committee. (Both, Charles Volkman.)

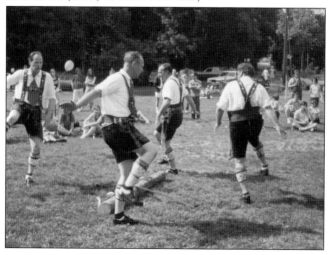

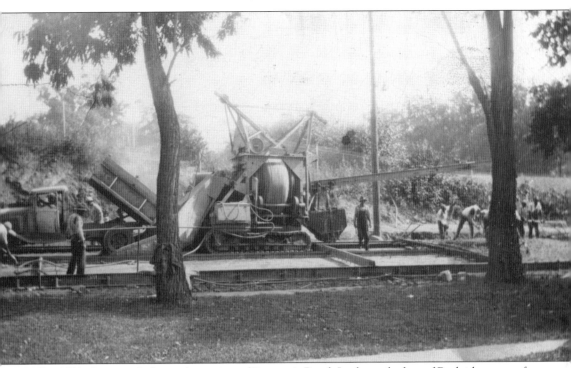

This 1932 photograph shows the paving of Reservoir Road. In the early days of Burleith, many of its streets were dirt roads. The improvement of the Burleith roads greatly increased the value of Burleith homes. In February 1931, the Executive Association of the Burleith Citizens' Association considered the advisability of protesting assessment of property owners of Burleith and adjacent sections who had received notices of assessments for the widening of Reservoir Road. The citizens had until March to protest against the assessments if they considered them beyond the value of the improvement to their properties by reason of the widening. The assessments were solely for widening and not for the paving of Reservoir Road, which is the southern boundary of Burleith and the northern boundary of Georgetown University. The final result was the widening and resurfacing of Reservoir Road from Thirty-Fifth Street to Foxhall Road. (Edgar Farr Russell III.)

These 1940s photographs, taken from S Street with views looking south over the Western High School stadium, show a collection of military barracks on the south side of Reservoir Road, located where the Georgetown University hospital is now situated. An April 1943 *Washington Post* article describes an antiaircraft battery near these barracks. The battery was part of a ring of such batteries around Washington, DC, built during World War II to fend off a possible German air raid. The battery was covered by artificial grass so that it was hidden from the air. If enemy aircraft appeared, the artificial grass cover could be quickly rolled back, allowing the battery to protect the city. (Both, Myles Johnson.)

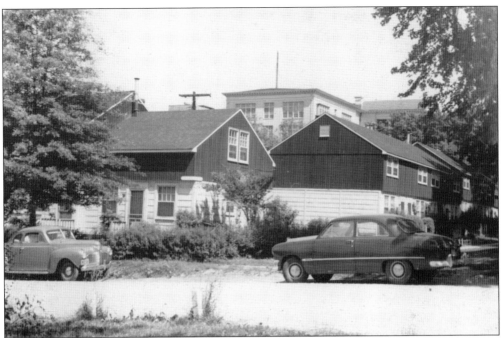

These photographs from 1951 (above) and 1945 (below) show temporary housing near the southwest corner of the intersection of Reservoir Road and Thirty-Fifth Street. The 70 temporary housing units, designed to remain for only one year, were built at the beginning of the World War II in 1942 on a golf course at that location. These buildings were erected in haste to satisfy an emergency housing crisis. They remained until 1955, when all temporary housing in the District of Columbia was razed. Georgetown Visitation Preparatory School owned the land, and in 1980, John F. Donohoe and Sons Company built a 153-unit townhouse complex called the Cloisters. These were three- and four-story brick townhomes offering an intimate residential experience. They included both garage and outdoor parking. The name *Cloisters* refers to the Georgetown Visitation Convent nearby. (Above, Historical Society of Washington, Kiplinger Library; below, Myles Johnson.)

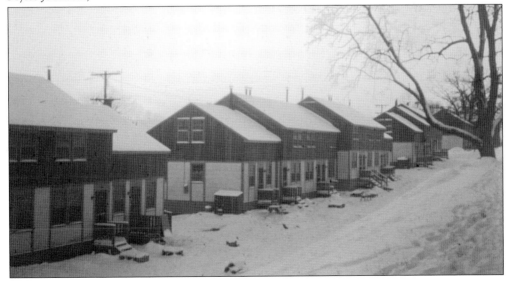

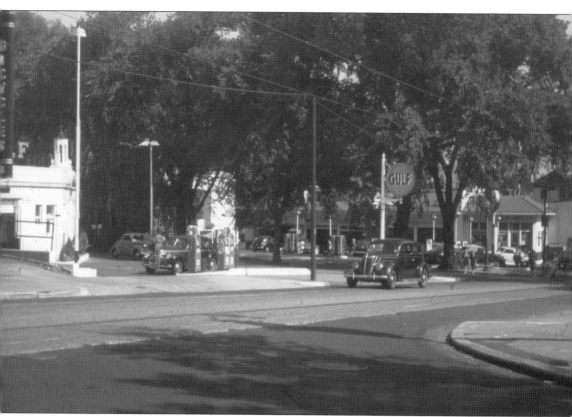

This photograph, taken in the early 1940s, shows two gasoline stations at the northeast and southeast corners of the intersection of Wisconsin Avenue and Q Street. While not in Burleith, these stations were the closest ones to Burleith at that time. Ironically, next door to the Gulf station on the northeast corner was the Georgetown Bicycle Shop. Lad Mills owned the station on the southeast corner. In 1942, the Office of Price Administration suspended both stations for 15 days for violation of gasoline rationing regulations. Mills was the vice president of Retail Gasoline Dealers, Inc. and volunteered his services to give women lessons in car repairs. In 1950, Mills, then president of the Association of Retail Gas Dealers of Washington, protested self-service stations. He stated his association was opposed to gasoline being pumped by anyone other than trained gasoline station employees. (Myles Johnson.)

These early 1950s photographs show the famous "Hanging Gardens of Burleith." They were located on the steep, cliff-like hillside that rises above the alley that separates the 1900 blocks of Thirty-Eighth and Thirty-Ninth Streets. There has always been an interest in the landscaping aesthetics by Burleithians. Beginning in 1926, Burleith had a garden club, which played an important part in the development of the neighborhood for almost 75 years until it was disbanded around the year 2000, only to be reborn in 2015. The club belonged to the National Federation of Garden Clubs. For many years, monthly lectures were held on topics ranging from the gypsy moth to nature photography. Beautification of the Burleith Tot Lot, created in 1977 at the old Fillmore School, was a notable project of the Burleith Garden Club. (Both, Edgar Farr Russell III.)

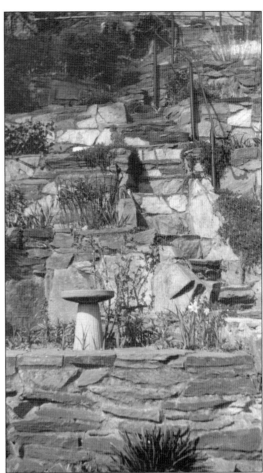

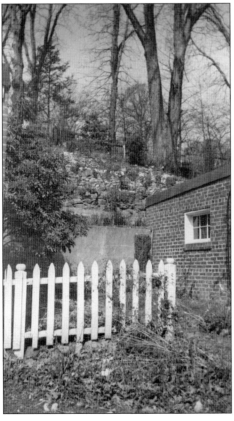

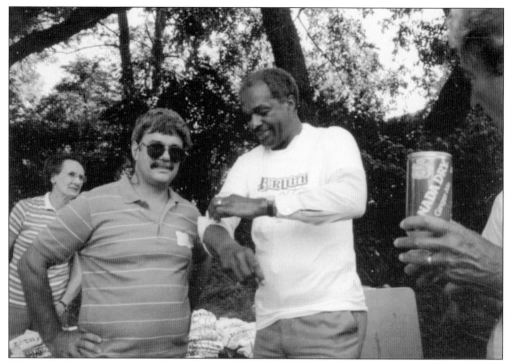

The Burleith Citizens' Association has sponsored a summer picnic every year since 1971. These June 1986 photographs, taken during the 16th Burleith summer picnic, show then Burleith Citizens' Association president Millington Lockwood and then–District of Columbia mayor Marion Barry, who attended the picnic. Millington was the organization's president from 1984 to 1987. The late Barry served as the second mayor of the District of Columbia from 1979 to 1991 and again as the fourth mayor from 1995 to 1999. These photographs were taken during his first term as mayor. Barry was a popular and influential figure in Washington, DC, earning the nickname "mayor for life," which followed him after he left office. Additionally, he served several terms as a member of the Council of the District of Columbia, before, between, and after his service as mayor. (Both, Susan Lockwood.)

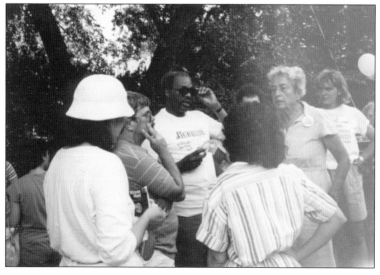

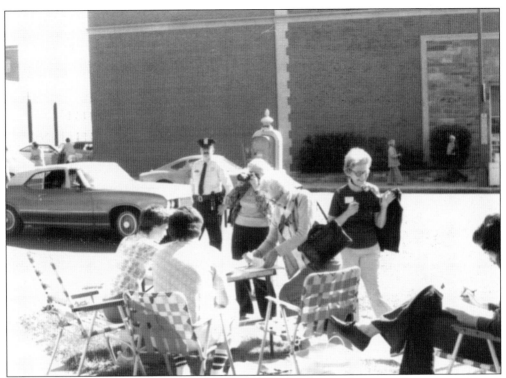

Starting in May 1970, the Burleith Citizens' Association sponsored an annual spring art show at Gordon Junior High School. These photographs were taken in May 1976 at the seventh such art show. Besides the policeman and police call box in the center, the image above also shows the facade of a Safeway store located at 1855 Wisconsin Avenue in the background. Known as the "social" Safeway, this store was built in 1954 and opened in February 1955. In late 1976, Safeway sought rezoning of a parcel of land behind this store, and a new store opened in May 1980. This was the second "social" Safeway, an upscale store frequented by the Washington elite. It too was eventually replaced, and in May 2010, yet a third "social" Safeway opened its doors at this location. (Both, George Washington University, Gelman Library, Special Collections Research Center.)

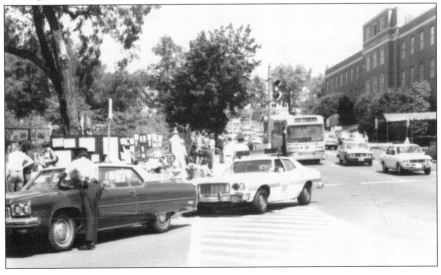

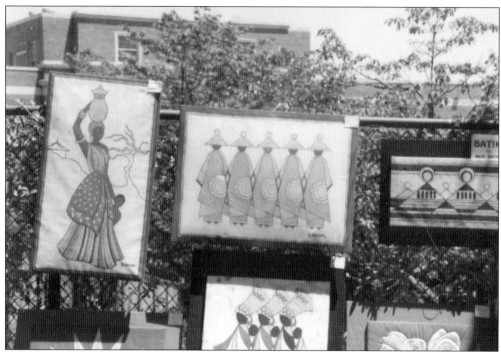

These May 1976 photographs were also taken at the seventh annual Burleith Art Show. Held at Gordon Junior High School, the art show not only provided an opportunity to see and purchase the best in local art but also supplied the largest portion of the treasury for the Burleith Citizens' Association. A highlight of this art show was a group of folk singers, who seem to have enthralled two youngsters in the audience. Three years earlier, at the 1973 Burleith Art Show, over 650 artists and antique dealers were invited as part of Burleith's 50th anniversary. That art show was cut short by a noon downpour, which caused many exhibitors to pack up for the day. The weather, however, cooperated for the 1976 art show. (Both, George Washington University, Gelman Library, Special Collections Research Center.)

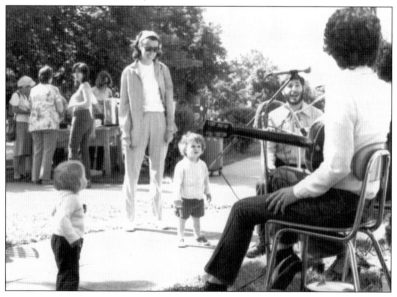

Five

THE EDUCATION OF BURLEITH'S CHILDREN

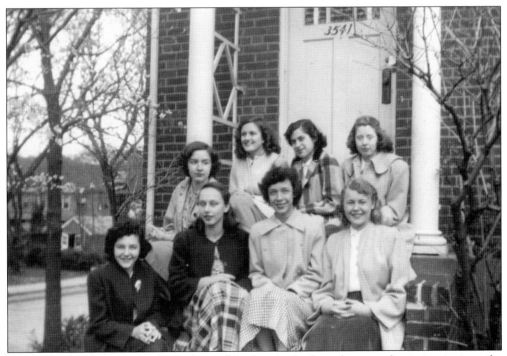

For most of its history, the Burleith neighborhood relied on three academic institutions for the education of its children: Fillmore Elementary School, Gordon Junior High School, and Western High School. This photograph by Nancy Lensen of other members of her Western High School graduation class of 1949 was taken in front of her home at 3541 R Street. (Nancy Lensen-Tomasson.)

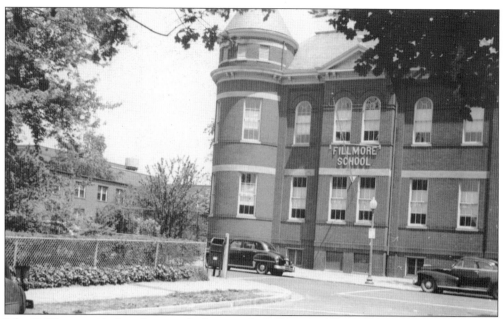

John P. Wymer took this photograph showing the Fillmore School located at 1801 Thirty-Fifth Street on May 13, 1951. The Fillmore School was built in 1893 at a time when most of Burleith was completely undeveloped. Named after Pres. Millard Fillmore, it stood ready to serve as the elementary school for Burleith's children when the majority of that neighborhood's homes were built in the 1920s. (Historical Society of Washington, Kiplinger Library.)

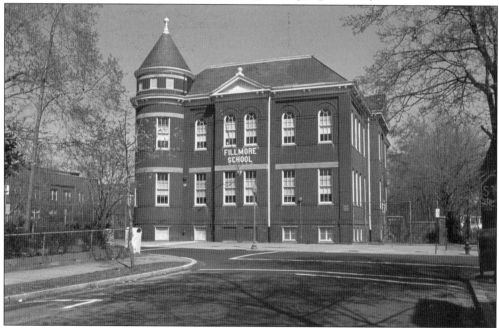

Emil A. Press took this photograph showing the Fillmore School on the east side of the 1700 block of Thirty-Fifth Street at the intersection with S Street. There are two entrances to the school building. The boys used the north-side entrance behind the circular tower, and the girls used the south-side entrance. (Historical Society of Washington, Kiplinger Library.)

In the late 1950s and early 1960s there were four teachers in the Fillmore School. A Mrs. Redfield taught kindergarten, Delores Middleton taught first and second grades, a Mrs. Mills taught third and fourth grades, and Bernadette Tennyson taught fifth and sixth grades. This June 1963 photograph shows Redfield in the classroom where she taught the kindergarten class. Marguerite Cunningham of 3528 T Street recalls that Redfield loved to play the piano and teach the children to sing songs. The children in the kindergarten class often painted with tempera paints and created colorful paintings, sometimes on long brown mural paper, which was hung on the classroom bulletin boards. In the mid-1950s, kindergarten was a more playful and pretend time for learning. The students were not doing paper and pencil worksheets and began formal reading, using Dick and Jane readers, later in first grade. (Marguerite Cunningham.)

The image at left, taken in June 1963, shows the sixth-grade promotion from Fillmore Elementary School. The boys are sitting on the left, and the girls are on the right. Each of the graduating students is wearing a mortarboard. Bernadette Tennyson, the fifth- and sixth-grade teacher, sits at the near end of the table facing away from the camera. Marguerite Varela sits to the right of Tennyson. At the far end of the table is the principal of Fillmore School. (Marguerite [née Varela] Cunningham.)

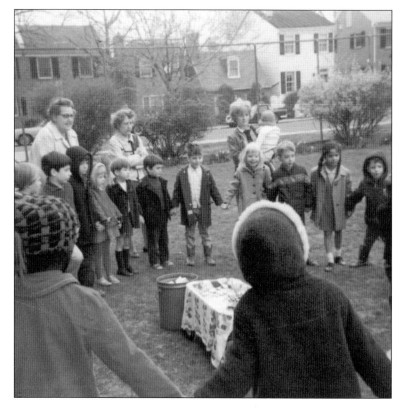

This photograph, taken in April 1967, shows Fillmore students standing in a ring next to the school. Some of the oldest homes in Burleith are in the background along Thirty-Fifth Street. (Mara Viksnins.)

In the June 1968 photograph at right, Fillmore School students clamber over a jungle gym made of metal pipes. To reduce the risk of injury from falls, today's jungle gym areas often have a thick layer of woodchips or other impact-absorbing material covering the ground, but this one sat on a concrete slab. The jungle gym was located on the site that after 1977 was occupied by the Burleith tot lot. The c. 1985 photograph below shows members of the Burleith Garden Club beautifying the tot lot. They are, from left to right, Frances Fort, Sara Revis, Sara Withers, Lucy Thrasher, Bonnie Hardy, Sylvia Thompson, and Sherrie Snyder. (Right, Mara Viksnins; below, George Washington University, Gelman Library, Special Collections Research Center.)

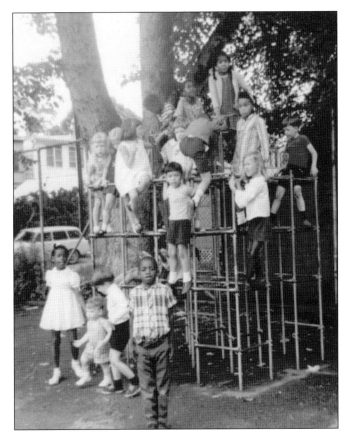

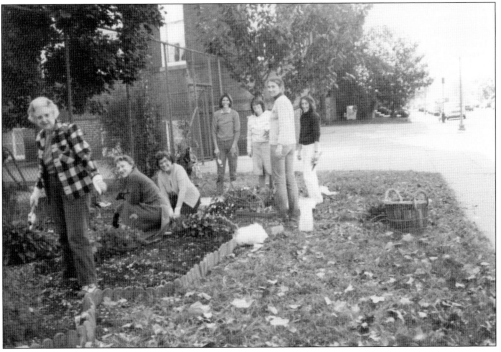

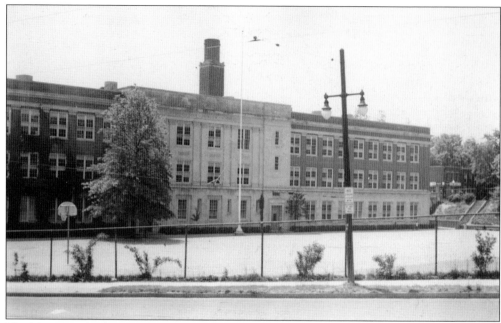

The May 13, 1951 photograph above by John P. Wymer shows Gordon Junior High School as seen from Wisconsin Avenue. The school was built in 1928 as the last homes of the Shannon & Luchs Burleith development were being built along Reservoir Road. The building kept the name Gordon Junior High School until 1980. In the background, barely visible just to the right of the school, is the Burleith Market, located in the 3500 T Street row house, built in 1909. Originally called Decklebaum's grocery store, the market had a diagonal entrance that has since been reconfigured to a side entrance. The market apparently closed sometime in the 1960s. Before the turn of the century, the area around the Burleith market was known as Bryantown. The 1940s photograph below shows students who have graduated from Gordon Junior High School. (Above, Historical Society of Washington, Kiplinger Library; below, Myles Johnson.)

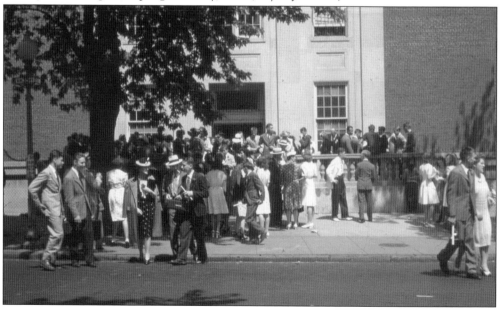

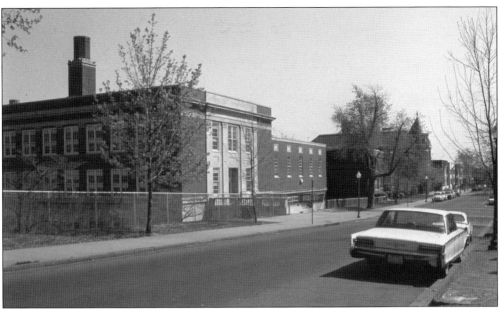

The 1968 photograph above by Emil A. Press shows an entrance to Gordon Junior High School, as seen in a view looking south along Thirty-Fifth Street. The Thirty-Fifth Street entrance faces the intersection with T Street. Gordon Junior High School played an important role in the education of Burleith's children until 1980, when it became the Carlos Rosario Adult Education Center. In 1996, it became the Rose L. Hardy Middle School. In the September 2008 photograph below, the words "Gordon Junior High School" are seen etched in stone near the roofline of the building. This is the only physical reminder of the junior high school that meant so much to Burleith's children for over 50 years. (Above, Historical Society of Washington, Kiplinger Library; below, Charles Volkman.)

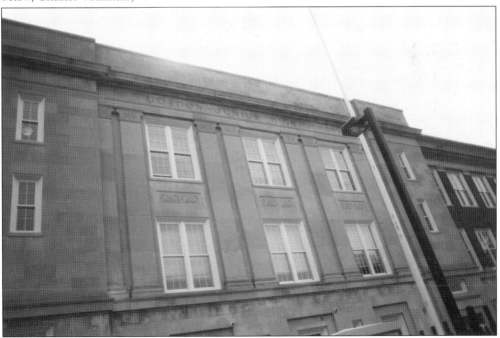

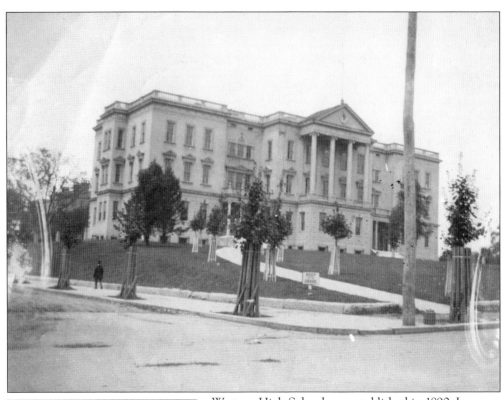

Western High School was established in 1890. It was originally housed in the Curtis School building on O Street. For its first 24 years, Edith C. Westcott was principal of Western High School. Beginning in 1891 with a handful of students and one teacher, she built up a school of 800 students and a faculty of 25. The first graduation exercises of the school were held in 1893. In 1898, this new building on the southeast corner of today's Burleith neighborhood was completed to house Western High School. The image above dates to around 1900 and shows the newly planted trees along with a Keep off the Grass sign to protect the new lawn. The photograph at left of Edith C. Westcott is from the 1924 Western High School yearbook. (Above, George Washington University, Gelman Library, Special Collections Research Center; left, Anne Garnier, archivist, Western High School Alumni Association.)

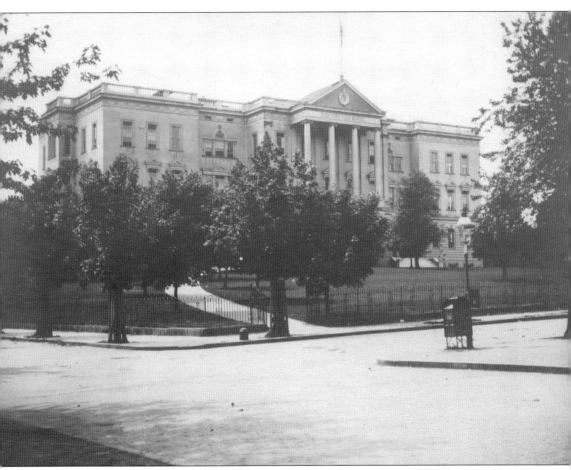

This image of Western High School is part of a collection of photographs of Washington, DC, public schools taken around 1900. It was taken a few years later than the previous image; the trees have grown, and a new metal fence surrounds the campus. Under Edith Westcott's leadership, Western High School progressed rapidly and increased in size. During 1911 and 1912, north and south wings were added to the building to accommodate a larger student body, and the original portico with only four columns, as seen in this image, was replaced by the larger portico, with its 10 Ionic columns seen in today's building. To the left of one of the trees is a small protrusion coming up out of the sidewalk. This also appears in the earlier image. To the authors, its purpose is a total mystery. (Historical Society of Washington, Kiplinger Library.)

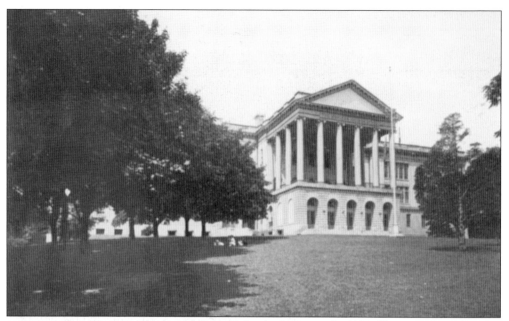

In 1923, Shannon & Luchs included this picture of Western High School in a sales brochure advertising the new Burleith housing development. There is no evidence of the massive fire that took place on April 24, 1914. On that day, Western's students and teachers came to the school as usual, only to find a huge crowd assembled around a building partially demolished by fire. The fire started early that morning, and the firemen were struggling to control the flames as smoke poured out of the windows. The students and faculty were moved out of the building into the Franklin School at Thirteenth and K Streets, where Western High School held its sessions until the following year. During the early summer of 1915, Edith Westcott resigned as principal and was succeeded in that post by Dr. Elmer S. Newton. (Above, Alfred Bigelow; left, Anne Garnier, Archivist, Western High School Alumni Association.)

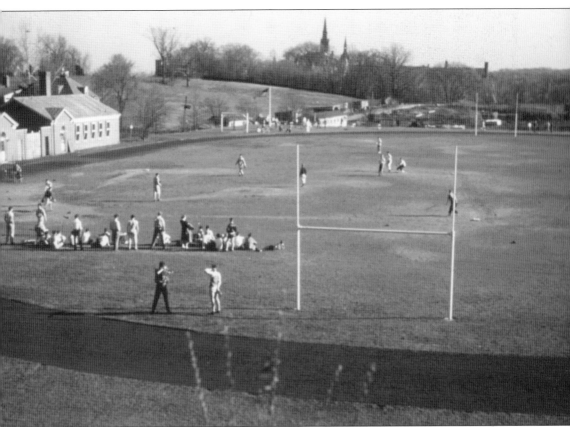

This early 1940s photograph shows the Western High School baseball team practicing on the Western High School field. The stadium sits in the southwest corner of Burleith; however, in April 1925, several years before the stadium was constructed, the Burleith Citizens' Association went on record in favor of the purchase by the District of Columbia government of a different site for a proposed athletic field and stadium for Western High School. The proposed site was a rectangle bounded by Reservoir Road, Thirty-Sixth Street, R Street, and 100 feet west of Thirty-Seventh Street. Building the stadium here would have required the removal of the House of the Good Shepherd. This did not happen, and the stadium was eventually built on its present site, bounded by Reservoir Road on the south and Thirty-Eighth, Thirty-Ninth, and S Streets on the other three sides. The site proposed by the Burleith Citizens' Association is now the home of the Washington International School. After 1974, when Western High School became the Duke Ellington School of the Arts at Western High School, the Western High School stadium was also called Ellington Field. (Myles Johnson.)

Strong rivalries existed between Western High School and the other District of Columbia high schools. This early 1940s photograph shows Burleith children painting the names of Western High School and Woodrow Wilson High School in the street in the 3800 block of S Street, no doubt with the hope that Western would be victorious over Wilson in an upcoming competition—and even though Wilson had saved Western in the early 1930s. In 1932, Western High School faced a serious congestion problem of too many students, which threatened to throw the school into a double-shift program. The solution to this overcrowding problem was the construction of Wilson High School; however, a $500,000 item for the construction of that school faced political problems in Congress. Even though Dr. Frank W. Ballou, superintendent of schools, lobbied for the item in the district appropriations bill, it was blocked in Congress in 1933. The new high school did not open its doors until the fall of 1935. (Myles Johnson.)

During the first two decades of its existence, the neighborhood of Burleith was a quiet, peaceful development where children played without the distraction of heavy traffic and commuters. Here are two early 1940s photographs taken by Iris Beatty Johnson of local children enjoying the idyllic and carefree lifestyle along S Street, between Thirty-Eighth and Thirty-Ninth Streets. What could have been better than playing football in the street or scaling a nearby tree—especially without the presence or interference of parents? Iris Beatty Johnson lived with her husband, Wynn, and their two sons, Humphrey and Myles, at 3829 S Street. (Both, Myles Johnson.)

25. Ezra Meeker as Frontiersman.

On June 4, 1934, the Western High School history club presented and dedicated a four-ton granite monument housing a 21-by-15-inch metal plaque that had been presented to the school on April 11, 1926, by Ezra Meeker (1830–1928), a 95-year-old veteran trailblazer who traveled the Oregon Trail by ox-drawn wagon as a young man. This undated postcard shows Meeker. The plaque he presented in 1926 sported an image of Daniel Boone based on an 1861 engraving by American artist Alonzo Chappel. The plaque was cast using metal recovered from the battleship USS *Maine*, after it was raised from Havana Harbor in 1912. The monument holding the Boone plaque and a smaller plaque containing the names of the officers of the history club remained intact for over 40 years until both plaques mysteriously disappeared, leaving a bare monument. (Edgar Farr Russell III.)

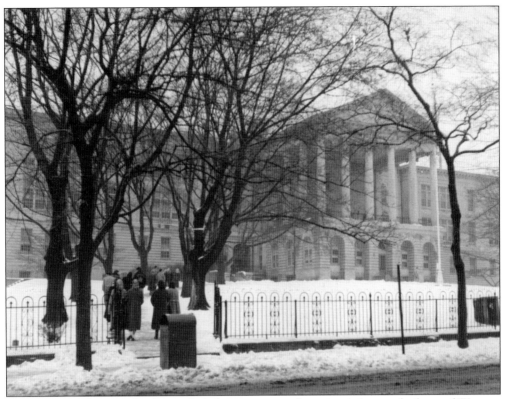

These c. 1950 photographs show a dark four-ton piece of granite sitting on the lawn of Western High School just behind the fence, to the far right in the image above and near the left below. This is the monument that was given to the school on June 4, 1934, by the Western High School history group, on which was mounted the Daniel Boone memorial tablet that had been presented to the school in 1926. A bronze plaque mounted below the Daniel Boone tablet contained the names of the officers of the history club: William Biggs, president; Geraldine Massey, vice president; Mildred Hull, secretary; and Peggy Dow, chairman. (Above, George Washington University, Gelman Library, Special Collections Research Center; below, Edgar Farr Russell III.)

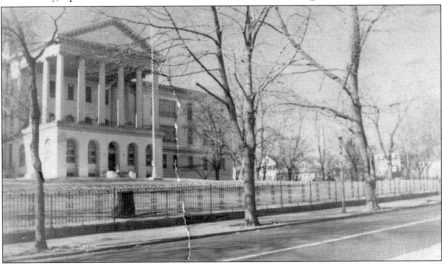

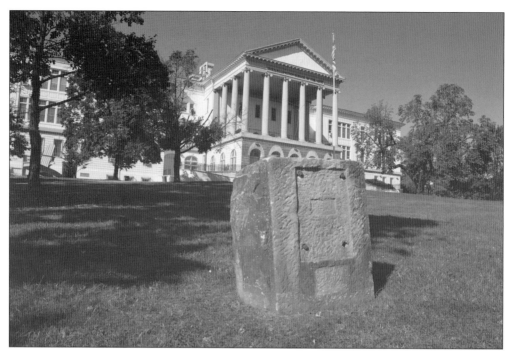

Sometime after 1974, the Daniel Boone memorial tablet and its accompanying bronze plaque disappeared. The photograph above shows a naked granite monument in front of the Western High School building exactly where it was placed in 1934. The Burleith neighborhood marked its founding with the March 1923 ground breaking by Shannon & Luchs of the Burleith development. As part of Burleith's 90th anniversary celebrations, a group of Burleith residents engaged in a project to replicate the Boone plaque and restore the monument. Although the original tablet was lost, the group discovered a plaque in the Davidson County Historical Museum in Lexington, North Carolina, cast from the original mold, allowing the fabrication of a replica to be used in the monument's restoration. The June 4, 2014, photograph below shows the unveiling of the restored monument. (Both, photograph by Linda Brooks.)

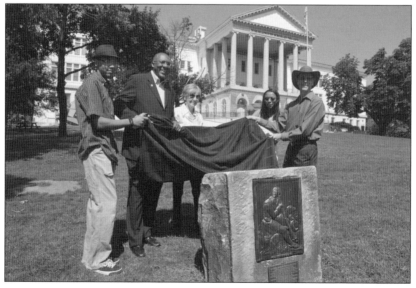

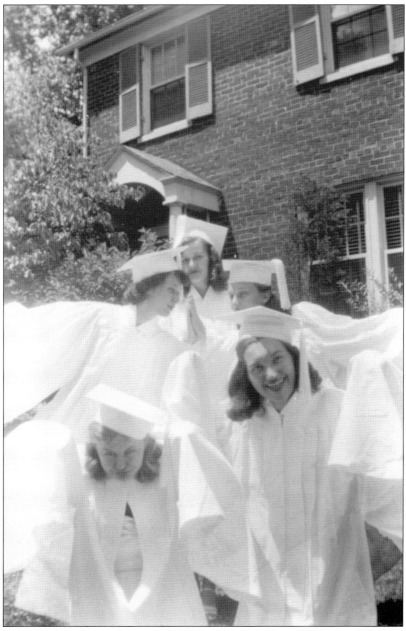

This 1949 picture was taken in front of 3541 R Street, the home of Walter and Kathryn Lensen. Their daughter Nancy Lensen, front right, had just graduated from Western High School. Clockwise from Nancy are Mary Virginia Heald, who lived in Virginia; Sue Wheeler, who lived in Foxhall; Juanita Brown, who lived in Virginia; and Junia Bratter, who lived near the Washington Cathedral. It is interesting to note that Western High School, one of the top-ranked high schools in the nation at that time, allowed students from outside of the District of Columbia to attend. Charles Volkman, the son of Charles H. and Anna Volkman at 3548 T Street, was also a member of the Western High School class of 1949. Three schools—Fillmore Elementary School, Gordon Junior High School, and Western High School—played very important roles in the education of Burleith's children. (Nancy Lensen-Tomasson.)

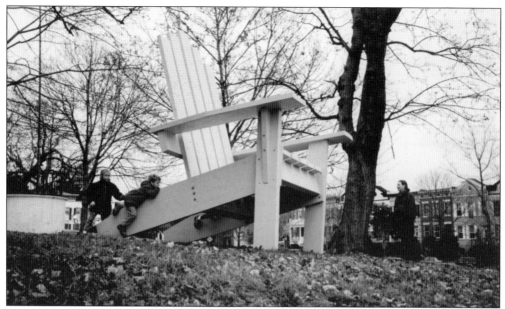

In 1974, a collaborative effort between Peggy Cooper Cafritz and Mike Malone developed into the Duke Ellington School of the Arts at Western High School, a joint partnership between District of Columbia public schools, the Kennedy Center, and George Washington University. The Duke Ellington School of the Arts has been compared to the New York's fabled La Guardia "Fame School." This big, green Adirondack chair is 14 feet tall and sits on the front lawn of the Duke Ellington School of the Arts. These December 1996 photographs show the chair soon after Duke Ellington students built it as a part of an art project. The art students repaint the chair yearly to keep it in perfect shape. It is a Burleith landmark, and visitors, especially children, often climb up to see what the world looks like from a big green chair. (Both, Mara Viksnins.)

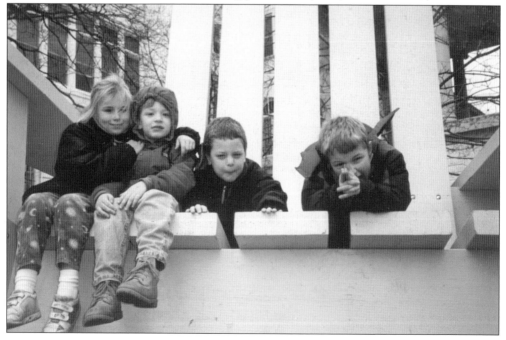

Six

THE WESTERN HIGH SCHOOL CADETS

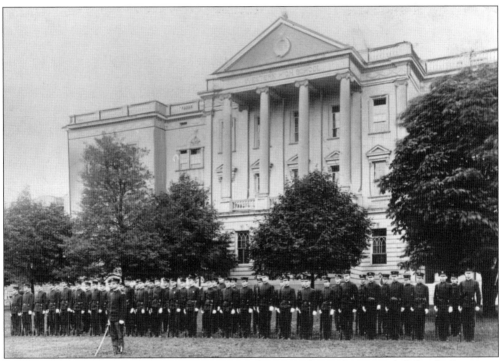

In June 1906, Pres. Theodore Roosevelt presented an award to Western High School's Company H after it won a competition. This was an early victory in a long string of successes by Western's cadets as they competed against other Washington, DC, high schools. The Washington High School Cadet Corps was first organized in 1882. This pre-1912 photograph shows Western High School cadets in formation in front of the school. (Historical Society of Washington, Kiplinger Library.)

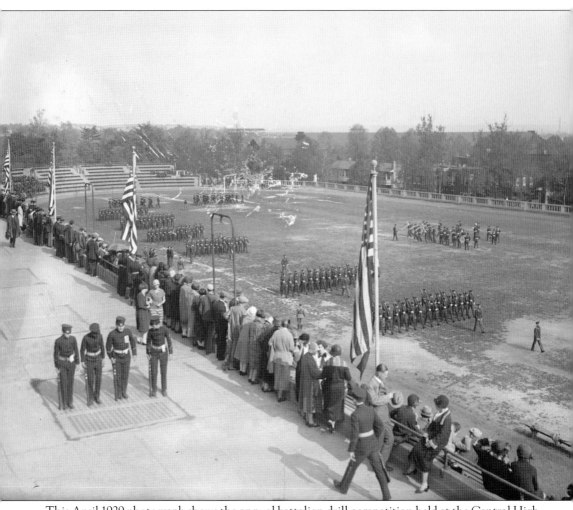

This April 1929 photograph shows the annual battalion drill competition held at the Central High School stadium. In that competition, Western High School's 2nd Battalion of the 4th Regiment won top honors. Cadet major Charles K. Denny was the commanding officer of the winning unit. As a result of this victory, Major Denny's 2nd Battalion of Western High School won a Colonel Craigie Cup, and Major Denny was awarded a gold medal. Col. Wallace M. Craigie was a professor in charge of military science and tactics for the district's public schools. Previously, Western High School had won a Craigie Cup both in 1924 and 1925 and, by virtue of the repetitive victory, won a cup for its permanent collection of trophies. Besides originating the cup in 1921 as a prize for cadet competitions, Colonel Craigie also took steps to create bands associated with the high school cadets. (Library of Congress.)

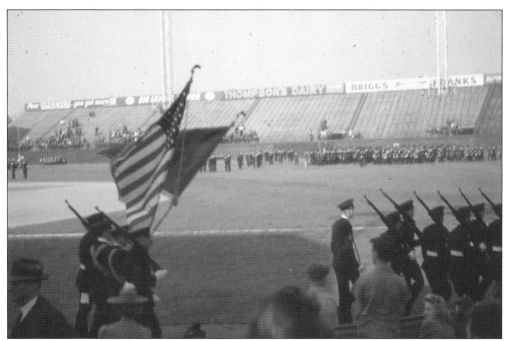

In 1941, Western's cadets won the regimental competition held at the Eastern High School stadium, which was followed by the battalion and band competitions, also held at that stadium. These were then followed by the company competitive drills, held at Griffith Stadium in early May of that year. These May 1941 photographs show the Western cadets coming onto the field at Griffith Stadium and marching past the reviewing stand as part of those competitions. Western won the competition in 1941. Originally called National Park, the stadium was renamed after Clark Griffith, the owner of the Washington Senators baseball team. The stadium was demolished in 1965 and this is now the site of the Howard University Hospital. (Both, Myles Johnson.)

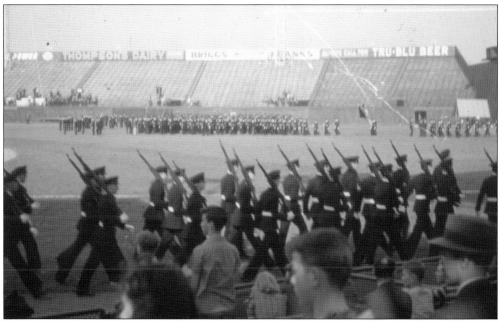

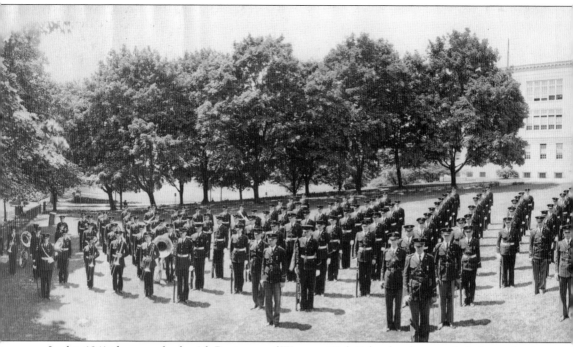

In this 1941 photograph, the 4th Regiment of Western High School cadets stands in formation in front of the school building. In March of that year, Western's cadet regiment won the competition held at the Eastern High School stadium. More than a thousand students, parents, and school officials watched while the cadet regiments from Eastern, Central, Roosevelt, Woodrow Wilson, McKinley Tech, and Western high schools went through their paces. The leader of Western's

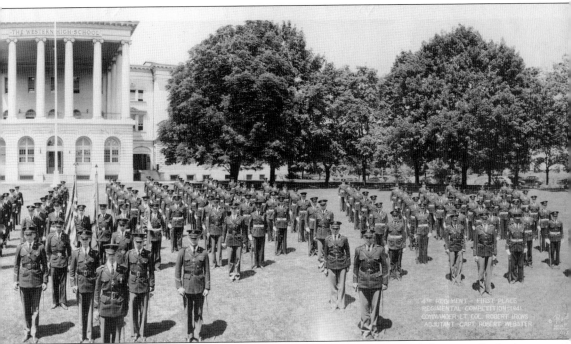

regiment was 16-year-old cadet lieutenant colonel Robert Irons of 3523 S Street in Burleith. Robert's father, who served in World War I, died when Robert was six years old. As a result of the victory, the regiment received a trophy and Robert Irons received a medal. (Historical Society of Washington, Kiplinger Library.)

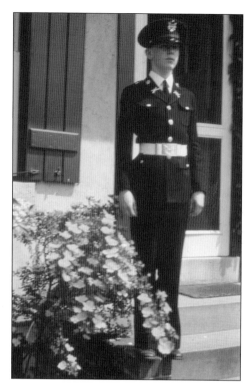

These 1941 photographs show Humphrey Johnson (left) and Myles Johnson (below) in their Western High School cadet uniforms. Humphrey and Myles are the sons of Wynne and Iris Beatty Johnson. The Johnsons were a "first family" of Burleith, having purchased their home at 3829 S Street immediately after it was built by Shannon & Luchs in 1927. Iris was a well-known illustrator of books for children, and her husband, Wynn, was also an artist. Humphrey, an editor and freelance writer, published a book, *The Perilous Journey*, in 1957 and was at one time managing editor of *Jack and Jill*, a children's magazine. (Both, Myles Johnson.)

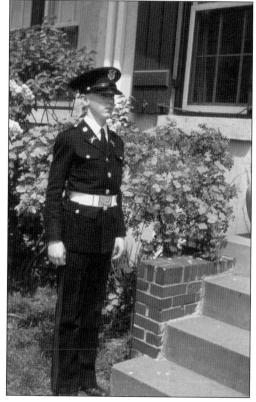

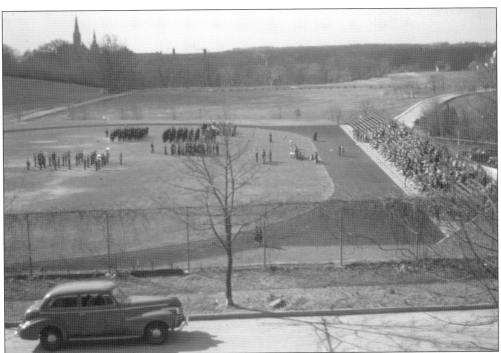

The Western High School cadets practiced at the Western High School stadium, later known as Ellington Field. From the early 1930s to the 1960s, the sharply dressed cadets marched along R Street from the school to their stadium. These 1942 images show the cadets working on their competitive drills at the stadium. Each drill required up to 17 movements and 50 commands. A crowd of neighborhood onlookers watches the practice from the bleachers on the west side of the stadium. Beyond the stadium in the above photograph with a view looking south across Reservoir Road is an empty field that will eventually house the Georgetown University Hospital. In 1942, World War II was about to begin, and this empty field would soon be filled with an antiaircraft battery and military barracks. (Both, Myles Johnson.)

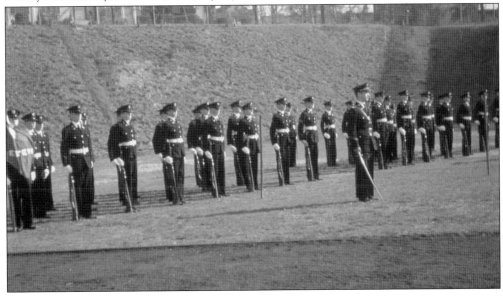

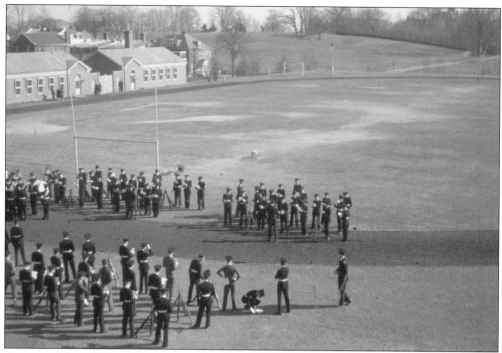

As part of their drill practice in the Western High School stadium, the cadets had to work at carefully stacking their rifles into a standing circle. One by one, the rifles were placed into position, and the slightest error could cause the entire circle to collapse. The image above shows a number of these standing circles. In addition, to the far left, the cadet band seems to be getting ready to play a march to lead the cadets back to the school. Taken with a slow shutter speed, the image below offers a sense of motion as the Western High School cadets leave the Thirty-Eighth and R Streets gate of the Western High School stadium and march down R Street to traditional marching calls and cadences. Both images were taken in 1942. (Both, Myles Johnson.)

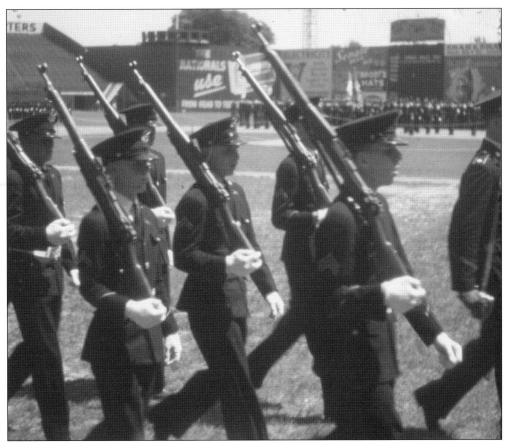

In May 1942, the Western High School cadets made an unprecedented sweep of the field in the company drill competitions at Griffith Stadium, winning the first, second, and third places and the Craigie Cup. The reviewing officer who pinned the awards on the winners was Western High School principal Elmer S. Newton, who was scheduled to retire in August. The winning Western units in the order of victory were Company H, led by cadet captain William Brandenburg; Company L, led by Capt. Hollis Kushman; and Company K under Capt. Robert Kibler. All three had scoring averages over 90 percent. With this win, Western continued a 21-year-old tradition of scoring in one of the first three places in the annual competitive drills. (Both, Myles Johnson.)

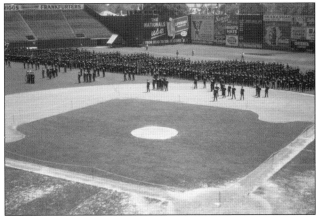

These 1943 photographs are from Western's next victory. Each time Western High School won the top honors in the annual district high school cadet competitions, the winning drill group won the right to keep the coveted banner with its flutter of ribbons from other winning companies of the past. The photograph at left shows a cadet holding the banner with the most recent ribbon to be added, that of Company H of the 4th Regiment, which won first place in the May 1942 competitions. In the 1943 competition, Western once again walked away in first place, as it had in 1941 and 1942 and would continue to each and every year through 1948. (Both, Myles Johnson.)

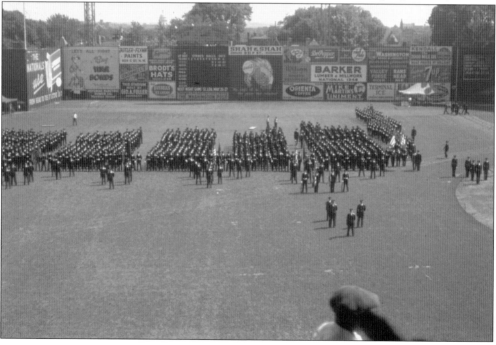

Every member of the Washington High School Cadets—and in particular, members of the Western High School Cadets—wore this cap badge on his uniform headgear. The cap badge forms the high school cadets' coat of arms based on the Great Seal of the United States and with the letters "HSC" for high school cadets over the eagle's head. Created in 1883 by George Israel, a teacher at the old Central High School, now Cardozo Education Campus, the Washington High School Cadet Corps originally consisted of two companies of 50 boys each. The corps was able to secure 50-year-old German muskets to arm one company, and during drills, one company used the guns while the other went through the foot movements and vice versa. (Both, Edgar Farr Russell III.)

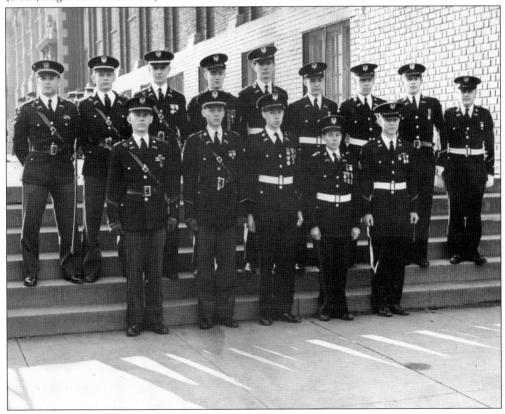

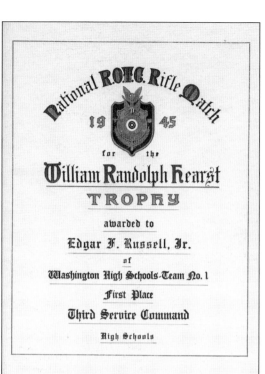

National R.O.T.C. Rifle Match

1945

for the

William Randolph Hearst

TROPHY

awarded to

Edgar F. Russell, Jr.

of

Washington High Schools-Team No. 1

First Place

Third Service Command

High Schools

In 1945, the Hearst Rifle Trophy was awarded to cadet captain Edgar Farr Russell Jr. of 3705 Reservoir Road, the leader of the Washington High Schools Team No. 1. This was the 25th consecutive annual competition in the William Randolph Hearst ROTC rifle matches, inaugurated by Hearst in 1921 for the purpose of cooperating with the war department and schools in stimulating interest in military training at educational institutions. The Third Service Command, created in August 1920, presented the award. In 1945, the command was headquartered in Baltimore and covered the District of Columbia, Maryland, Pennsylvania, and Virginia. Edgar Farr Russell Jr. is in the first row, second from the right. The commanding officers of the various commands throughout the country allowed eligible high school teams in the competition, along with universities and academies. (Both, Edgar Farr Russell III.)

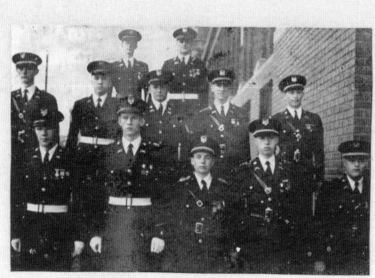

BRIGADE RIFLE TEAM
WASHINGTON HIGH SCHOOL CADET CORPS

WINNERS
U.S. ARMY 3RD SERVICE COMMAND RIFLE MATCH
THE WILLIAM RANDOLPH HEARST TROPHY MATCH

This retirement photograph for Capt. Edgar Farr Russell Jr. USNR (Ret.) was taken in August 1984. Born in May 1927 to Ida Frazier Russell and Edgar Farr Russell Sr., Captain Russell was reared in Burleith. He attended Fillmore Elementary School, Gordon Junior High School, and Western High School, where he served as captain of Company K of the Washington, DC, Corps of Cadets. (Edgar Farr Russell III.)

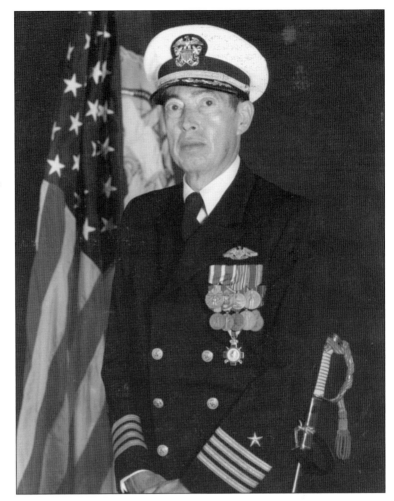

This is Captain Russell's Company K pennant. He graduated from Western High School in June 1945. In June 1942, the National Rifle Association awarded Edgar Jr., at age 14, an expert rifleman medal. One of only 260 youngsters nationally to be so honored in 1945, he averaged 80 percent accuracy for 50 shots standing 50 feet from the target to earn the award. He served in both World War II and Korea. (Edgar Farr Russell III.)

On April 12, 1940, the Western High School Cadets Band competed in the annual regimental and band competition at the Central High School field. The result was McKinley High School's band winning first place and Roosevelt High School's musicians taking second. Third place ended in a triple tie between Central High, Wilson High, and Western High. The companies' competition was held on May 13 and 14 at Griffith Stadium, where these photographs were taken. Additionally, the six cadet drill teams competed at Griffith Stadium for the diamond-studded Allison Nailor Medal. The winning band received an award along with the winning company, a system meant to emphasize the importance of the bands to the morale of cadets. (Both, Myles Johnson.)

Seven

Burleith's Fire and Police Call Boxes

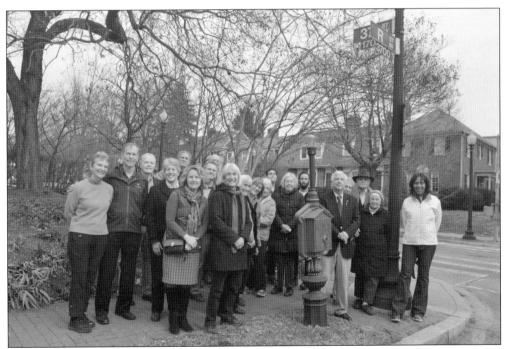

Beginning in March 2013, the Burleith History Group spearheaded the restoration of Burleith's fire call boxes, which had been deteriorating since they were abandoned in the late 1970s. This February 2016 photograph shows residents and friends of Burleith celebrating the completion of the restoration project. The call box shown here is known as "Shorty" because it has settled over two feet into the ground. (Photograph by Linda Brooks.)

Initially, the fire call boxes were wired to send telegraph messages to the fire department. Later, they were retrofitted for telephone communication. Each one had a door that could be unlocked to send an emergency message. The district's call boxes were discontinued, and their electronics were removed in the 1970s when the 911 system of emergency contact was fully established in the city. The door of the fire call box on the corner of Thirty-Seventh and R Streets was lost. During the restoration, this missing door was replaced by a bas-relief sculpture by Jeannette Murphy, a Burleith artist. The sculpture reflects two nearby historic events. On the upper portion are the Western High School cadets who marched past this call box on their way to and from drill practice at the Western High School stadium. The lower portion depicts the notorious spy Aldrich Ames leaving a signal to his Soviet handlers on a mailbox located across the street from the fire call box. (Photograph by Jeannette Murphy.)

Fire insurance marks were the symbols of fire insurance companies during the last decade of the 18th century through all of the 19th century. Their use was precipitated by the lack of full-time professional fire departments, which did not come into existence until the 20th century. As a consequence, the fire insurance companies filled the void by providing fire protection through the use of either their own firefighting equipment or that of volunteer companies. These two fire marks are found on two Burleith homes. They are the symbols for the Fire Association of Philadelphia. The marker to the right appears on 1800 Thirty-Fifth Street, built in 1900, while the marker below appears on 1810 Thirty-Fifth Street, built in 1894. Fire call boxes did not come into use until later in the 19th century. (Both, photograph by Linda Brooks)

Burleith has five fire call boxes. Except for an older one located on the southwest corner of Thirty-Fifth Street and Whitehaven Parkway, these fire call boxes were presumably installed in the 1920s along with the Burleith development. The fire call boxes were in use until the 911 emergency call system was introduced in the late 1970s. The abandoned call boxes were left to rust until 2015, when they were finally restored by a project financed by the residents and friends of Burleith. This 1945 photograph by Iris Beatty Johnson shows the fire call box on the northeast corner of the intersection of Thirty-Eighth and S Streets. On the far right of the row of Shannon & Luchs houses, obscured by trees, is 3718 S Street. In 1944, this house was the home of George Middleton, a descendant of Arthur Middleton (1742–1787), one of the signers of the Declaration of Independence. (Myles Johnson.)

This June 1950 photograph by John P. Wymer shows the fire call box on the southeast corner of the intersection of Thirty-Sixth and S Streets. Like the one in the previous image, this fire call box has a long light pole with a large glass globe on the top. At some point after 1950, the light poles were replaced with shorter versions, and the glass globe was replaced with a smaller glass dome to protect the lightbulb inside. When the original fire call box system was abandoned in the 1970s, the electronic innards were removed, leaving only a metal shell. Washington, DC, is one of the very few cities whose remnants of the call box system were left in their original street locations. Each of Burleith's restored fire call boxes now boasts a plaque describing some aspect of Burleith's history. The plaque on this call box addresses the origins of the name *Burleith*. (Historical Society of Washington, Kiplinger Library.)

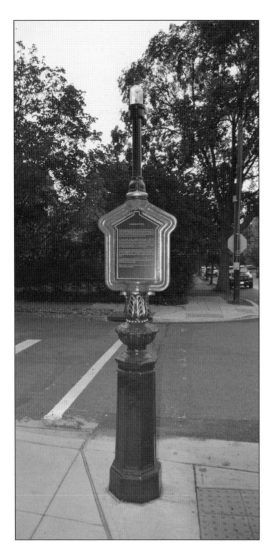

Although they represented a bygone era when they were the primary means of summoning the fire department in case of emergency, in 2013 Burleith's fire call boxes were rusting hulks. That was the year the Burleith History Group took on the project to restore Burleith's fire call boxes. The restoration used two historically accurate colors revealed during an experimental activity to strip away rust and old layers of paint—red for the housing and black for the pedestal and light pole. Gold highlighting was added for aesthetic reasons and does not represent a color associated with the call boxes in earlier times. These photographs show two sides of the completely restored call box at the corner of Thirty-Sixth and S Streets in Burleith. (Both, photograph by Linda Brooks.)

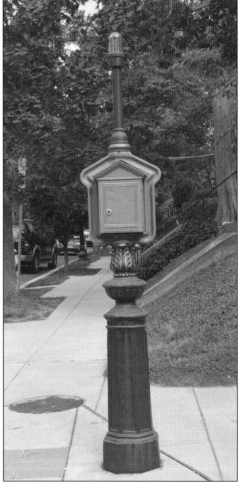

Each of the restored Burleith fire call boxes has a plaque describing some aspect of Burleith's history. The image at right is a prefabrication rendering of the plaque placed on the fire call box at the intersection of Thirty-Sixth and S Streets. Its topic is the origins of the name *Burleith*. The image below is a rendering of the plaque placed on the fire call box at the intersection of Thirty-Seventh and R Streets. This is the call box that is also known as "Shorty." Its topic is patriotism and espionage: patriotism because the Western High School Cadets marched by this call box on their way to the Western High School stadium to practice their drills, and espionage because a Soviet spy used chalk marks on a mailbox near the call box to signal he had information to divulge. (Both, Artistic Bronze Plaques.)

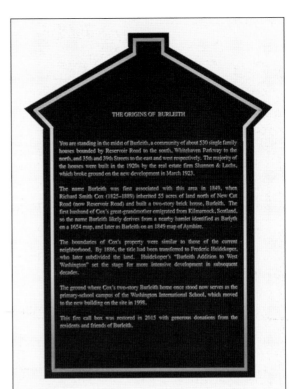

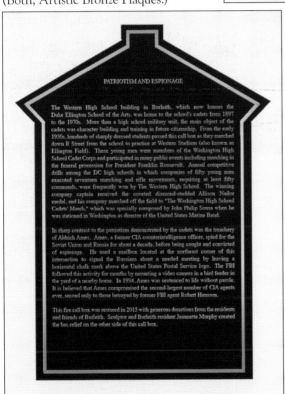

The fire call box visible at the lower left in this 1989 photograph sits on the northwest corner of Thirty-Seventh and R Streets. It is called "Shorty" because it has sunk almost two feet into the ground. The reasons for this sinking are a Burleith mystery. There are two main theories. The first has to do with what appears to be a pond near Thirty-Seventh and R Streets that can be seen in a 1924 aerial photograph of the Burleith neighborhood. The other theory revolves around what, in another photograph, appears to be a burning dump. To the right of the house on the corner is 1702 Thirty-Seventh Street. This was the home of Frances Lewine, the first female full-time White House correspondent for the Associated Press, serving during six administrations (1956–1977). She led the fight against discrimination in the journalism profession and was one of seven women who filed a successful class action against the Associated Press in 1978. The "Ames mailbox" used by the convicted spy to signal his Soviet handlers was across Thirty-Seventh Street from Shorty. (Sarah Revis.)

Fires in Burleith are rare, but there are a few important exceptions. In 1914, Katie Fleniken lived at 3530 T Street, shown in this April 1968 photograph. On April 24 that year, she discovered a fire in the Western High School building. Fleniken first saw a flickering light, but in a few minutes she realized that the structure was burning. Leaning from her window, she shouted "Fire!" After others took up the alarm, someone telephoned No. 5 engine company, and the firemen responded. Western principal Edith Westcott and several Western teachers reached the building in time to identify where the valuable school records were kept. These records were placed on the ground near the building and later moved to the Fillmore School building. The Western building was so badly damaged that Western's students were moved to the Franklin School, located at Thirteenth and K Streets, and the school held its sessions there until the following year. It was believed that the fire started in the chemistry laboratory. (Jerald Clark.)

These photographs show damage from a June 4, 1994, fire that began under the porch of 1714 Thirty-Seventh Street and eventually gutted that house as well as 1716 and 1718 Thirty-Seventh Street and damaged 1712 Thirty-Seventh Street. Robert Greenwood, a 38-year old waiter and White House volunteer, was trapped inside a rented basement apartment and died in the fire. There was an earlier and larger event, the "Great Fire of Burleith," in October 1927. Five Burleith homes on Thirty-Seventh Street (1803, 1805, 1807, 1809, and 1811) and a sixth on S Street (3635) were badly damaged in that fire. Because of street construction on S and T Streets, a fire engine became stuck, delaying the fire department's response to the fire. Fortunately, no one was injured in that earlier blaze. (Both, Burleith Archives.)

In addition to fire call boxes, Burleith had, at one time, three police call boxes. Emil A. Press took these two photographs. The one above, taken in December 1965, shows a police call box on the northwest corner of Reservoir Road at Thirty-Fifth Street. In the background is Western High School and just inside the fence in front of the car on the right is the Daniel Boone monument. The photograph below, taken in April 1968 with a view looking northeast, also shows the police call box and on the northeast corner of the intersection, the Western Pharmacy. Sometime after the 1970s, all of Burleith's police call boxes were removed, and today, only historical pictures remain to show where they once stood. (Both, Historical Society of Washington, Kiplinger Library.)

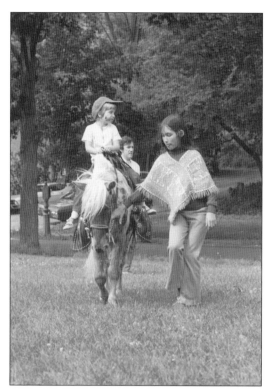

These photographs, taken in June 1973, show a pony ride at the third annual Burleith summer picnic. The first summer picnic took place in 1971. Since that time, the summer picnic has taken place every year. The 1973 summer picnic coincided with the 50th anniversary of the ground breaking for the Shannon & Luchs Burleith development. A police call box near the west side of the intersection of Whitehaven Parkway and Thirty-Fifth Street is visible in one image just to the right of a tree trunk. A third police call box once stood on the southeast corner of Thirty-Sixth and T Street. It is unknown why Burleith's police call boxes were removed while the fire call boxes remained. In Georgetown and some other Washington neighborhoods, both the police and the fire call boxes remain. (Both, George Washington University, Gelman Library, Special Collections Research Center.)

Burleith resident Iris Beatty Johnson of 3829 S Street took this early 1940s photograph. Though not a Burleith scene, it shows a very steep and narrow flight of 75 stone steps in Georgetown leading down from Prospect Street to Canal Road, the C&O canal and the Potomac River. Henry and John Threlkeld's Alliance estate extended from near this section of the river northward to include the present-day Burleith neighborhood. The Capital Traction Company built the stone stairs in 1895 on the side of a carbarn used to house cable cars when Washington still used a trolley system. The stairs are prominently featured in William Friedkin's 1973 classic horror film *The Exorcist*. Prior to the film, the stairs were known as the Hitchcock steps, in honor of director Alfred Hitchcock, even though Hitchcock never used these stairs in any of his films. Now known as *"The Exorcist* stairs," they became a district landmark and an official tourist attraction in October 2015. (Myles Johnson.)

DISCOVER THOUSANDS OF LOCAL HISTORY BOOKS FEATURING MILLIONS OF VINTAGE IMAGES

Arcadia Publishing, the leading local history publisher in the United States, is committed to making history accessible and meaningful through publishing books that celebrate and preserve the heritage of America's people and places.

Find more books like this at
www.arcadiapublishing.com

Search for your hometown history, your old stomping grounds, and even your favorite sports team.